FINDING FERAL

a memoir

andrea pardue

To request permissions, contact the publisher at
andreapardue44@gmail.com

Scripture quotations marked TPT are from
The Passion Translation*.
Copyright © 2017 by BroadStreet Publishing* Group, LLC.
Used by permission. All rights reserved.
The PassionTranslation.com.

Paperback: ISBN 978-1-7372159-0-5
Ebook: ISBN 978-1-7372159-1-2

First paperback edition August 2021

Edited by Celia Medrano-Ortiz
Cover and inside art by Andrea Pardue
Layout by Lynne Hudson
Author Photograph by Ben Deckert
Book Production by Tell Your Stories Publishing

Printed by Ingram Sparks in the USA

Publisher

www.strongwhisperer.com

To John Pardue, my husband,

for giving me the beautiful space to call home that is us.

FINDING FERAL

A Spacious Reclaiming of Life

Introduction

Not Broken

ONCE UPON A time there was a little girl who loved her mother. Every day she served, survived, and played. Then one day, she grew up and found herself motherless and spent of her sensibilities. Her emotions were buried so deep away from her heart that nothing seemed real anymore. The colors in the flowers were just an illusion, intangible. Even the air she breathed left her choking.

I'm terrified to be visible and to face the depths of the difficult things in my life. Mostly, I feel mortified to be seen. I want to be tucked away in my own private world, imagining, diving into things of my own making - unseen, uninterrupted.

The cage I had built to protect myself from the awful things I had seen, from love, death, and dying, and the torment of living had

turned into my own trap. This trap had left me paranoid and unable to handle even the most basic stimulations of life.

I am realizing that the defense mechanisms that were necessary to protect me as a young person have become obsolete and only hinder and block my growth now. My defense mechanisms are the ways that I distance myself from the full awareness of my unpleasant emotions.

When I try to sort out my life experiences, they jumble together, like clips and scenes from a thousand movies flashing before my eyes in a stream. It is hard to capture any one. It just rushes by relentlessly. How do I begin telling my hard and triumphant story? Why am I compelled to even go through this marathon to write my story? Because I am welling up with an incredible compassion to share a voice of healing and possibility. I want all the things I have learned and experienced to be a part of the whole of humanity. I can understand the darkest places of the soul, and I want to reach down into that dark pit with compassion. I want to find the light on the other side where that spark of passion is hiding, and not let my voice be quiet. I am becoming bold and feral, wildly willful, and unrelentingly curious in exploring myself. I am becoming a gentle claimer of authority.

Meeting My Mother

I HAVE KNOWN such a great love in this life. It has seeped into the fabric of me. I don't want to tell my sad story. It feels boring. If I do not acknowledge and get to know my tragedy, it will be hard for me to find the treasures and triumphs on the other side. There are treasures that have been hidden in darkness.

I had a mother that suddenly experienced severe chronic illness in her early 30s. I was nine when I first witnessed the dire suffering of my mother. I spent the next 26 years helping her stay alive and watching her tormented in this life. Then she died.

It is very painful to give the full acknowledgement of what I have lost. What I have had is, perhaps, uncommon. I had a powerful force of love in my life from my mother. I have been unsure about how to go

about reckoning with something that big, that significant.

Sometimes I wonder if I was spoiled or jaded to have known such an unconditional deep love. It was made all the richer through our family suffering together, side by side, in the battle to keep my mother alive. She never stopped or was thwarted from loving or supporting me in every way she could muster up the strength. She washed my dishes when I had babies despite excruciating nerve pain in her legs. She went out with me on fun dates even while her body was malfunctioning. There were times in the dressing room of Anthropologie that I wondered if I should call for medical assistance or just block out her dire state and enjoy playing dress up together, soaking up that moment of pleasure and delight with her. She deemed it worthy of the energy and capacity that she didn't have.

She could have so easily gone into focusing on herself, justified by her constant physical torment. She could have been bitter and disgruntled. She could have sucked in the energy of her family's emotions to try to sooth the unsatisfiable of her condition. Instead, she persevered, gaining strength from a higher Source, and building a vast compassion for others. An outpouring of something unique, wonderful and life giving.

Her compassion and love for others was transcendent. I see it in the letter she wrote to her niece, encouraging and spurring her on in

the demands of life. My mom wrote, "I know things have been challenging for you and I think about you and pray for you." Everyone in her life got this tender loving touch of concern from her. She had an enduring love and compassion for others. It is something I have always thought deserved more commemoration. It's the beauty of her life, the irrefutably powerful counter to her suffering that shines ever more brilliantly. Yes, we endured the trauma of her suffering, but we also drew in a wealth of gracious love.

My mom talked weekly with her best friend, Jan, while she was still alive. "I miss your mom every day! I want to call her every time something happens that impacts me," Jan wrote to me recently in a card. What a reflection of a depth and safety in friendship. My mom wanted, and was eager, to know the deeper journey of her friend.

Mom flew across the country to be with Jan when her husband died early in his life, leaving his young family behind. Mom and Jan often reflected on their relationship as being akin to Jonathan and David in the Bible. It reflects the willingness to be there no matter what. *I've got your back. I'll go through anything with you. Our hearts are combined.* It's a relationship reflecting the very heart of love and loyalty.

Dan and Lily Smith are some of our oldest and closest family friends. My mom met Lily at the health club where she worked.

They connected as middle-aged women beginning to have serious health issues way too young. Dan was our family physician. Our families clicked and became loyal friends. We often went to Taco Bell after church for $.50 tacos. When I cut my knee on a nail, Dan stitched me up in his office Sunday morning before church.

They remember keenly how much she was constantly in the Word (reading or meditating on the Bible). I read in her journals about how much she meditated on verses, claiming their truth with all of her might. It has always baffled me a little. I am too cynical perhaps. Or I just don't identify with that kind of resource. Or maybe I have never been in the complete state of physical desperation that she was in all the time. Communing with God that way was a source of power for her to keep going.

I seem to find the same inspiration in the mysterious air of creation which, I believe, is equally connected to knowing God and Her power. I just got back from an overnight in the wilderness, and I feel like I have 20 extra springs in my step. Creation provides such a personal and intimate interaction with Creator.

My mother pursued, with all of the strength she could cling to from the universe, to really live out the fullness of her life. Despite the relentless battle of her health crisis, she was so humbled by her experience of life. She had to fight past the insecurities of feeling useless.

One of her greatest drives in life was to be useful. My kids had a book that was about an inch worm that would go around measuring things. He did it to show the other animals they shouldn't eat him because he was useful to measure them; then they could know how long or tall they were. He found his simple way of contributing. My dad and I would lovingly refer to mom as an inchworm because she loved being useful and accomplishing things. Maybe that deep inherent drive to participate also helped to raise her above the impossibility of her health and partake fully.

It has been hard for me to approach these powerful aspects of my mother because it involves delving into an even greater grief of what I have lost. Not encountering this loss blocks me from still hearing the presence of her voice that is left here on earth. I have had several people tell me that they see her in me, carrying something on. I guess she is in my essence now. It lightens the weight of feeling that she is so starkly gone and silent. I feel a little less frozen in knowing how to encounter the depth of that loss.

I love this note I found in a card my mom wrote to her friend. It shows the simple graciousness of her spirit. She acknowledges that life is challenging but doesn't seem to have expectations for anything to be different. She is accepting. She has gratitude.

"This is a difficult time for me. Every day is so hard, but I do see God working in my life and others, but it is easy to lose perspective and feel hopeless and helpless (as you know). My health seems worse if anything."

- Peggy Jo 2002

The Fall from Health

I WAS TEN and my brother Adam was seven when an unforeseen force began to invade our lives. This big, invisible monster came landing down in the middle of our security. It started eating away at the beautiful things that gave us a sense of grounding. It was an ugly monster of circumstance. It was inside of my mother, taking away her ability to participate. It stripped her down to a basic level of survival. It twisted food and drink into the enemy and made her skin crawl invasively with pain. We were helpless to this unnamed thing. This pervasive destroyer.

This monster began to give the first inklings of its presence when my mom started to have digestive issues and the first tingling of nerve pain. She charged forward as she usually did to tackle whatev-

er came her way. She talked to her doctor. Diabetes seemed a viable explanation, so they scheduled testing.

To test for diabetes, you consume large amounts of sugar to see how it affects your blood sugar. Our family went to McDonalds for breakfast before school, a rare treat. My mom dutifully poured syrup on her pancakes. She never consumed much sugar because she had always been sensitive to it. She asked us to pray that she wouldn't throw up all that nauseating sugar. After breakfast, my brother and I got dropped off at school. We innocently went along our day with the warm feelings of our special family communing that morning, while feeling the strangeness of something unusual happening.

I still carried that innocent warmth with me when I was picked up from school that afternoon. However, instead of going home, dad took us to the hospital to see mom. She lay in her hospital bed looking pale and weary. Her blood sugar levels had sky-rocketed to life threatening levels. Her pancreas had almost completely shut down. It took days for them to get her blood sugar under control. She had fragile diabetes, the kind that is really hard to regulate as it jumps around so sporadically. Her new life of pricking fingers and insulin injections had begun.

She was determined to be the best diabetic she could be by eating the right diet, consistently testing her blood sugars and exercising.

In whatever she did, she would be gung-ho and 1,000% invested in what she took on.

Along with the diabetes, her body made this immediate shift into extreme and constant pain from a sudden onset of nerve damage. Her digestive system was partially paralyzed, causing incessant nausea. The ever-present dilema became to keep her hydrated and nourished. It was a sudden and drastic attack on her body. An invisible war. My dad jumped into the battle blindly looking for weapons and a strategy to fight. Home IVs barely kept her alive. Intermuscular shots did nothing to alleviate the pain.

One moment, mom was radiant and energetic, and the next moment she was precariously close to death. She had been the head of the aerobics department at a health club while she gracefully carried on her role as mother. She was inspiring and her demeanor contagious as she came into herself in midlife. It's that golden time of parenting where your kids can feed, wipe, and dress themselves and yet they still adore being tucked into the center of the family. I admired my mother as she bounced out front, leading the way. She had been charging forward in her independence.

Dr. Smith had come alongside our family not only as our physician but also as a loyal friend. He was doing everything he could to keep my mother alive by putting her on IVs at home. "We were just

watching her die of dehydration and malnutrition. I didn't think she was going to make it," said Dan.

I came home from school one day and found my mother in bed, an IV needle sticking out of her arm. The clear line snaked up to hang from a shiny metal pole. This was attached to a bladder of clear liquid. The once comforting room of my parents had turned unfamiliar. The safety I had so recently felt was transported obscurely. Any concept of what was happening was intangible. I stood in the doorway of her room, afraid to enter. I was frightened of the unfamiliar situation I found my mother in. It was grotesque in its desperation. I said a quick, monotone hello and left the room. I was scared to get close to what looked like my mother. It was the situation I was scared of. My small, undeveloped mind didn't yet know how to distinguish and separate the two.

My mother stayed in bed for the next two months. At best, she could keep down a little Carnation Instant Breakfast. She was withered and worn thin. The devices she was constantly entangled in had crossed the situation over to something that smelled more desperate.

I came home one day, and my parent's friend was sitting at her bedside playing a guitar and singing to her. It all smacked of unsettling. You don't serenade someone at their bedside unless something is really, really wrong. It was like I didn't know where my mother was

and what this strange situation was that had replaced her.

As a little girl, I hardened myself.

Not Safe

MY FIRST REALLY big discovery at the age of ten was that life is not safe. The people that you love and depend on the most are not immune to being taken out. What did my ten-year old heart conclude with that information?

1. You need to not need anything.
2. All energy and resources should go to Mother.
3. Above all, we need Mother.

So, I diminished myself. I made the inside of myself as small as I could. I found a long, dark hallway in the shadow of my soul and tucked myself into it. This was the beginning of the story I would tell for myself. I took this hard experience and figured out how best

to decipher what it was telling me about life. What would I then conclude? How would I cope? How would these rules shape me?

I made an impacting rule. I must not need anything, and I must make myself very small. I lived out of the harshness of that rule until my middle life. It paralyzed me in so many ways to know how I was even allowed to function or take up space. I did it in small ways by staying out of the way, holding back, staying in the corner and not saying how I felt. Just hold it inside, I told myself.

My mom came out of that dire state after a year. She was able to continue taking on that generous loving role of a mother. It felt like every cell in her body was for me. I was given a deep affirmation from her. When I was sick, I felt the intensity of her compassion. I remember feeling surprised at how bad she felt for me. Really hard shit was to come, but the treasure of my mother's generous spirit would be mine to hold in my heart.

I grew up with a dual normalcy. One of a loving and supportive mother and the other of a mother whose reality was managing diabetes, chronic pain, and nausea.

Understanding what was happening with my mom in this incapacitated state had become disconcerting. Dr. Smith decided to send her to the Mayo Clinic in Rochester, Minnesota. Mayo is a collaboration of advanced medical resources and knowledge. "When

you can't figure it out locally, you send out to the big clinic," Dan had said.

Going to Mayo Clinic was my parents' desperate attempt to figure out what was going on with my mother's health and how to handle it. At Mayo they confirmed that my mom had Type 1 diabetes, which made her completely insulin dependent. Her nerves were being damaged in the digestive system and were partially paralyzed. They tried using drugs to get it to revive, but there was no response. Basically, her digestive system was shutting down. Not a good situation when one is trying to stay alive.

My parents would stay at Mayo for a total of one month over the next year. My mother became the 'lab rat' in experimental testing. Her already miserable state was intensified by the sanctified torture of each test. They had her swallow a radioactive substance so they could watch how it traveled through her system. They stuck needles deep into her muscles. The already burning nerves were lighting up with volcanic pain.

In the hotel room, after a day of testing, my mom was laying on the bathroom floor, throwing up. She told my dad to pray for her. My dad replied, "What's the point? It's not going to do anything." My mom responded defiantly, "Don't say that about God. God is God. He can be as mean as He wants." She stubbornly believed in

God's rightness. I would later feel devoid of having any connection to feeling that there was a goodness about God. She didn't need an explanation, evidence, or proof. It just was. This defiant faith in God brought her through some unbearable and relentless dishing out of this life. It gave her the strength of Source beyond her human body and mind to persevere.

Adam and I were staying with our grandparents and friends while our parents were at Mayo. Normal life ceased during this year. I wish I had a memory of what I was feeling or doing at the time. Was I taking a hiatus from school? Was I sitting around playing cards with my grandparents, making their famous chocolate cereal cookies and cinnamon raisin bread? I only remember my cousins and I got to stay in a hotel while visiting my parents when they were at Mayo Clinic. My two cousins and I choreographed synchronized swimming in the hotel pool. This was also the first time I saw my dad cry. He was standing outside next to a car in a parking lot sobbing. He looked so helpless and disheveled. I didn't know what to feel. I was bewildered and numb.

I didn't know how much desperation he was in trying to figure out how to keep his wife alive. He would break down everywhere he went. At the bank, the teller would give him a kind greeting and he would melt into tears. At church, someone would say, "Hello,

how are you doing, Don?" Meltdown. If he was at the grocery store and someone asked if he needed help? Forget it. Watershed. I don't know how he held everything together. Working, providing, caring for two young kids, school, homework, food, house, and keeping his wife alive.

Mayo confirmed through testing that she had neuropathy in her digestion. Neuropathy is defined as a nerve problem that causes pain in different parts of the body. They diagnosed her more specifically with peripheral and autonomic neuropathy. This causes pain that is stabbing and burning. The doctors told my parents that they didn't understand the cause of her neuropathy. It is really strange for this kind of nerve damage to come on so suddenly. It usually happens after years of neglect from not regulating blood sugars properly in diabetes.

Mayo Clinic couldn't answer the big question. How do we treat this? The testing had felt like another kind of monster's torment. They still had no defense. Dan was scrambling to figure out a solution. He was in this fight to the death with my parents. If there was any way possible, Peggy was not dying on his watch.

In his searching, Dan discovered a brilliant neurologist in Rapid City. Dr. Stewart was a cutting edge, out of the box thinker. He looked at mom's test results from Mayo and diagnosed her with

Reflex Sympathetic Dystrophy (RSD). This is a mysterious condition without clear options for treatment. Simply put, RSD is the term used to describe a chronic condition characterized by severe burning pain. I'm not sure how helpful this was, but she got diagnosed with perpetual severe burning pain. I continued to watch my mom struggle with this year after year for the rest of her life. She was sentenced with severe nerve damage and partial paralysis of her digestion resulting in chronic nausea.

This was where my mom's spirit of determination came in. She was insatiably ready to face anything. Sure, she got discouraged, but she never gave up. Life was too important to her. I have often been confounded by the significance of how much she was willing to persevere through to be fully present for this life. What made it so worth it to her? The crazy love and connection she had to her family and friends inspired her to cling to life with every last bit of her being, no matter how tormenting. I have never been able to refute a tremendous power and significance in that. I have sat at times wishing for the end of this life to come immediately. Then I remember what my mother was willing to go through just to participate in it, no matter how decrepit and broken her body was. Surely, I could muster up some sense of hope to persevere and partake.

Dr. Stewart had been experimenting with treating patients with a Hyperbaric Oxygen Chamber (HBOC). Hyperbaric Oxygen Therapy (HBOT) is a medical treatment used to help boost the body's natural healing process. In a HBOC, the air pressure is increased two to three times higher than normal while being filled with pure oxygen. Under these conditions, the lungs can gather much more oxygen than would be possible by breathing pure oxygen at normal air pressure. The HBOT further allows for oxygen to be dissolved in the blood. These oxygen rich fluids in the body can then travel to areas where blood circulation is blocked and help to heal nerve damage.

The HBOC is a big metal contraption. The patient slides into a chair and puts on a mask to breathe the pure oxygen. The heavy door is sealed and closed securely, much like being put into a submarine. There is no getting out from the inside. It's good to not have issues with claustrophobia when using a chamber. Once the door is sealed, it pressurizes as though one is diving 50 feet under the water. Treatments last between one to five hours. It takes a lot of calm patience to have a treatment. It really helps if you enjoy reading. Mom loved reading.

Dr. Stewart had found a study in a medical journal about nerve damage in lab rats being reversed with the use of a HBOC. This

gave him enough medical evidence to justify using the HBOC to try treating my mother. He had a chamber in his office to treat patients experimentally and offered to treat my mother for free.

She responded to the first two sessions dramatically. It was the first actual weapon of defense my parents found in this battle. Due to the healing power of the treatments, she was able to start eating and drinking again. The chamber treatments would help her feel better for a couple of days, then all the pain and digestive issues would come back. Using the chamber regularly was a key to helping her get a lot of relief from the digestive issues and pain from the nerve damage that was mostly in her legs and feet.

After one year of consistently using the chamber most every day, she was able to reduce treatments to 2-3 times per week. She would still struggle off and on with pain and digestive issues, but her condition had vastly improved from the dangerous state it had been.

As my mom stabilized, I still got to have those special mother moments. When I had chicken pox pretty badly at the age of 12, her tenderness and compassion towards me is still something I carry tucked into my heart. I had a 104° temperature and in order to bring it down, she had to give me a cool bath. It felt like torture to place my burning body into the stark contrast of the cold. Her

empathy for me was palpable. I gained the courage to take the cold bath treatment as I was held by her compassion.

I started taking classical ballet lessons when I was seven. The graceful, disciplined expression of the body drew me in intuitively. My mother would take me to ballets during the year: the Nutcracker, Sleeping Beauty, and La Fille Mal Gardee when the Australian Ballet came touring. They did The Chicken Dance, which tickled us with its graceful cleverness and comedy. I wore a black velvet dress. Waiting in line to enter the theater doors left me with an excited anticipation to take our seats. I looked up at my beautiful mother and felt like the most special little girl in the world. We held hands and looked at each other in delight as we watched the performers, entering a world that seemed to have been created just for us.

I felt reassured that it was going to be ok. Her warm, courageous eyes told me that my vivacious mother would be back. She was not weak. She was determined. This was manageable.

Whidbey Island

THE SUMMER BEFORE I started high school, we moved from Rapid City, South Dakota to Whidbey Island, Washington. My parents had lived on Whidbey Island when they first got married. They were renting an old Victorian house in a cute little seaside town when I came into the picture. My dad had longed to get back to the great Northwest. Some pieces of his heart must have remained there. On a trip to visit friends while he walked the beach, he asked himself, "Why do we not live here?"

They had just lost the use of the chamber as it had been sold to a hospital that didn't do experimental treatments for RSD. My dad found some investment property on the island that was situated on an oceanside cliff. He planned to design, build and sell houses. We

lived in one of the houses for a spell. I had a bedroom that looked out on the ocean. Sometimes I would wake up at night to see the moon glittering upon the water.

My mom was able to continue her HBOT by commuting to Seattle, a three-hour drive roundtrip. I was in the throes of teenagerhood and its focus on self. It was really a blessing for me during that time to be so me-minded as I became more oblivious to the disconcerting daily condition my mom still suffered in. It was a brief respite.

Whidbey Island provided an amazing playground for outdoor adventures. My brother and I were the perfect playmates in this season of our common interests. We combined our newfound independence that being 16 & 14 afforded with the fire and vigor of our age. We rollerbladed all over that island. We land luged, skateboard sailed, surfed, kayaked, sand boarded, paddle boarded, and hiked.

I love that we had this time of being wild and carefree. I think it really gave us a sense of our inner instincts. It gave us a feral voice of our inner creature that longed for an outlet. It let us know vividly what it felt like to be really alive and participating in the creation surrounding us. To feel the wildness of being alive, untamed and unmasked. It was a pure encounter of life.

Whidbey Island is a magical place tucked into the corner of the United States. It is approximately 40 miles long snaking along

between 1.5 and 10 miles wide. Adam and I considered it our natural playground with cliffs, beaches, coves, and winding fir lined roads. It had the beautiful madrona with its green smooth flesh and paper red bark, open prairie land that looked out to ocean and mountain range views, thick forests and most importantly, miles of oceanfront land.

After school, we would often find ourselves hiking along the seaside cliffs of Fort Ebey State Park. It was a total separation from our everyday life. Pettiness spilled away from consequence as this massive, life-filled ocean, and towering cliffs of rock, sand, trees and grasses spread before us. This place where eagles took their perch observing a vast surrounding. Seals frolicked the cold waters. As we hiked along, we each found a spot to take our own perch on the natural bonsais that live atop the cliffs.

We had found two tuckamore or krummholtz trees distanced just close enough to each other. These trees are the original, wild bonsai. They are described as, "crooked, bent, twisted, wood." They are also referred to as flag trees which are a living weathervane as they show the direction from which the breeze has been blowing for centuries. The tuckamore tree tells a tale of resilience and strength. "They inspire us with their tenacity in the face of harsh conditions." – as they say in Finland. Krummholtz means "crooked wood" in

German. These, "Old trees are those that grow slowly by surviving tough environments at the extremes of their tolerance limits," declared Sperduto. I am a kindred spirit to this kind of life.

The fat trunks went up to three times our height. The trunk abruptly turned 90° into the forest, away from the ocean. Nature's bonsais do this to protect themselves from the tremendous vigor of the ocean winds' relentless beatings. Their wood gets tough and hard. I can only begin to imagine the sheer force of wind that must have caused this over so much time. Centuries? These were resilient old trees to be revered.

We were part of the serene as we sat atop each of our trees perched like eagles, quietly in our stillness as we looked out. We didn't speak as we sat atop our tree bends. We just beheld, reverent in the majesty of earth, our souls filled with gratitude. Even though we didn't use our voices, I felt this special connection to my brother from those moments. We shared something deeply mysterious, similar to surfing together in the cold Northwest waters. We watched each other ride natures waterpower that beamed giddy in the deepest chambers of our hearts. Every cell screaming with pleasure at being a participant in the vibrating canvas of creation. We were written in. I am a pulse that takes up beautiful space. I am intentional. To embrace that takes all the guts and gall of my courage and vulnerability. It takes

being tremendously humble to accept this risky beauty. It takes a gratitude without expectation.

I think of those bonsais transforming and bending to such harsh conditions. I think of their wisdom and their experience. I think of how they have toughened up and become incredibly strong. I think of all that they have witnessed.

I find myself feeling like a kindred spirit to those trees. Life throwing its harsh conditions at me, relentless and long. I behold how special these trees and their experiences are. I picture them in winter storms, wind ripping around trunks, withstanding incredible assaults. They cling to their cliff home because that is where they have been placed. They did not choose this spot; they fell into it as an innocent seed. They grew into it. Life's torment happened. They stood fast and let the bluster strengthen them. Turning their vision old and wise after the years of hardness. A reckoning of the superfluousness of life instead of being blown away. What solid and heavy things are left behind? They hold onto what can truly sustain them.

My Parents Grapple

WHILE ADAM AND I were having teenage island adventures, my parents were still grappling with my mother's severe health issues. After moving to Whidbey from Rapid City, they were tasked with finding a HBOC to continue using. They found one in Seattle that they went to several times a week. It was a three-hour drive round trip for each treatment. The rigors of travel became wearing.

Our close family friend, Dick Kimbell, was observing mom's degression. He and his wife Marge were adopted grandparents to us. Dick commented that, "The light has gone out of her eyes" from the strain of it all and the continued decline of her health. He took it upon himself to help facilitate my parents acquiring a different kind

of access to a chamber from a guy who owned a company for deep sea diving the oil fields off the shores of Scotland. He had developed a chamber for individual use. He had been inspired to help his sister who had Multiple Sclerosis. He happened to be selling his company and moving back to the US along with three of the chambers he had created.

Dick helped my parents raise the nearly $40,000 through personal and community contacts to purchase the chamber. When the sale was to go through, they were short of funds, so Dick collected together all of his business contacts from the community in Oak Harbor, where we lived, to sign off on a personal loan for my parents to help the purchase go through. They did eventually raise all the money to pay off this loan.

I am astounded to realize the community of people that surrounded my parents in exceeding ways. From our friend, Dr. Dan Smith giving her IV treatments at home, Dr. Stewart providing the gift of chamber treatments at his office, the hundreds of people that contributed funds to provide a chamber for my mom, Dick and Marge who orchestrated the funding, the Oak Harbor business community that put their personal money on the line to facilitate this purchase. I am floored, flabbergasted, gut-wrenchingly grateful for the compelling compassion of all these people.

Even as the universe revolved around my teenager self, I was struck by the power of friends and community. My mom was able to maintain her health for the next couple of years until new complications kicked in.

Fort Ebey

FOR A WHILE, our family lived right on the beach of Whidbey Island. If I walked South, down the beach, turning the corner around a cliff, I found myself spilled into Ft. Ebey State Park. It had lovely cliff top hikes along the ocean and a fantastic little point out in the water that a westerly or northwest swell could line up with the Straight of Juan De Fuca and roll in perfectly curling swells right up to the beach. The rocky formations under the water created a nice long peeling wave to ride. Most of the time the water was completely flat because the Olympic Peninsula blocks the open waters. It was a glorious treat when the swells line up to make it into this nearly private surf spot.

Adam and I spent a lot of time checking the swell and found

ourselves looking at a flat ocean half of the time. Then we would proceed to do what teenagers do best and dork around at the beach. We stacked rocks in clever formations and played "butt crack", a little game we made up.

The person not taking their turn sits on a rock a couple yards away from the player, making sure that the back of their pants is puckered out enough for the player to throw a stone into the gap of the pants. In each turn, the player got a specific number of throws and would count how many times the rock made it into the crack.

The biggest tide changes happen in the Spring, along with some nice wind storms out at sea to produce bigger swells rolling into shore. We would find this beautifully calm Spring day that would pour in overhead waves at times. It doesn't happen too often but when it does, its epic. It also feels like your own special secret that you waited diligently and checked regularly for. Most of the time, we would come out to this point and there was not even a lick of swell, so it was an exciting surprise when the swells lined up, and we could take a little break from playing "butt crack".

My brother and I spent an entire week one spring out surfing because the swells and tide had lined up so beautifully. We spent hours every day in those gorgeous head high swells. We only went to school if it didn't interfere with surfing. My face became like leather

by the end of the week and my brown hair streaked blond. My hair was like straw from the daily salt water I had not washed out. My skin always had a thin salty layer on it that I prized as a badge of honor. I still have these fine lined crow's-feet from that week. The measure of tides became our primary indication of time.

We came home from surfing one day to find our front driveway full of firetrucks and ambulances. We stepped into the open front door to a house full of strangers. We looked to our dad, weary and sagging, his eyes blank. Adam went over to him and placed his hand on dad's arm to inquire what was happening. Then we saw mom being carried out by the EMT folks. She was unconscious. Dad didn't seem to have words. No one else could tell us anything. They were busy getting mom loaded into the ambulance. Dad followed directly behind her and loaded himself into the back of the ambulance.

Adam and I stood in the driveway watching for minutes or hours. It was hard to tell. The silence between us was comforting. We were together in our sorrow. Perhaps we went into the house and slumped ourselves into chairs, biting our nails or just staring. We didn't have a way to call dad. We waited for news.

It was not uncommon for Mom to not be feeling well. My dad would know things were getting serious when she couldn't eat. This caused her body to go into a diabetic ketoacidosis (DKA). When

the body is not getting enough glucose for energy, it breaks down fat in the liver and turns it into a chemical called ketones for fuel. It's essentially like eating yourself. Her ketones were off the chart high. This is very dangerous and can cause brain swelling and coma.

This had been one of those times. Mom had not been keeping food down for awhile. Dad had been vigilantly checking on her. One of the times he checked on her, she was passed out and wouldn't wake up, so he called 911. Adam and I showed up in the middle of the ruckus.

The wild beauty of our adventures juxtaposed with the harshness of mom's reality.

Stars

URING MY JUNIOR year of high school, I got it into my head that I wanted to walk the several miles to school just for the experience of it. Part of the walk was along the ocean, and the rest was through winding forest roads. I would hit the road at five in the morning so I had enough time for the 1.5 hour walk. I have a knack for loving to do things the hard and long way just for the experience of it. Those kinds of adventures are timeless for me.

My first morning to walk, I headed out to the road in pitch black. I hadn't realized how utterly dark the island could be at night. The glory was that impossibly filled sky of stars. Bright glowing space embers with a backdrop of darkest night. I felt I had entered my own special realm. My entire walk was filled with a magical awe. I

arrived at school in an altered state. I knew something secret that was wonderful.

"One with the dark, companioned by the stars."

-Legends of the Low Country, DuBose and Heyward

The next day of walking was void of stars as the clouds had tucked themselves into all the sky spaces above me. Those clouds were wet, wet, wet. Not a downpour but a constant leaking for the whole walk. A very dependable Northwest-style rain. The dampness made me feel at one with the atmosphere around me, like I was absorbed into the breath of the air. A great blue heron was fishing in the marsh lands near the beach. A kingfisher plummeted in the saltwater for her breakfast. It was another mystical space that I found myself in. Like everything around me was being its very self just for me. I felt giddy underneath my rain suit. My face dripping with carefree delight. I was tucked into all this moisture. It was cleansing and nourishing. I arrived at school soaked with a satisfaction complete. I knew another secret.

I got my brother to join me one day for the walk home. We took the long route that wound our path mostly on the beach. It became a game between us as we crossed a field full of white daisies to see who could fill their arms the fullest with flowers. We were delighting in

nature's gifts that were whimsical and extravagant. Our souls filled with the senses of the earth.

I have this thing inside me that wants to be a bit untamed. It wants to take the long road because my instinct says there is something important to find there, not because it makes good rational sense, but because there is a treasure to find that is worth going out and getting a little wet and muddy for. Why do I have a deep longing to know how dark the night is, how bright the stars are, how moist the air can be, how still the eagle sits, and how twisted the bonsai can get? It is speaking a language deep within me. It says there is something solid, real, and tangible I get to behold and be exactly in the center of. Creation speaks the language of soul. Mysteries are revealed in the unspeakable. A language that can be touched, tasted, smelled, and felt. A language that vibrates.

I have found this raw liberation in tapping into this feral part of myself. Suddenly anything is possible. There are no restraints. I am released of rational confinements and letting the core of myself kick in. It feels true. The laws of the universe are my keepers. I become raw beauty along with the earth.

Believing I am a gem of the earth is the hardest thing. It's what my fear fights me endlessly on. My fear wants to grab me and pull me into confinement. I know it is trying to protect me as well, but it

can't be the only thing. There gets to be something wild and spontaneous that has a say also. Most of all, I need to know how utterly valid I am, a child made on purpose, of the earth and also eternal. My spirit comingling with body and soul.

Weather Wild

I WOKE UP to the wind blustering against my bedroom window. The sky was righteously alive. Grey mixed with white in fluffy ominous precipitation and gusto. A deep spark of excitement was welling up from my belly, moving up towards my throat, continuing up to cause a buzz in my brain. A hum of excitement for wild, powerful weather that is showing this other thrilling facet of its character. I wanted to feel the intimate fullness of this force, the personality of this constant companion on earth.

I quickly dressed, making sure I had a worthy shield of protective covering on my body. I slipped into the car with single minded focus; my attention anticipated my destination. Driving the curves of the island fed into the adventure in my veins in a reassuring and

mysterious welling. The tall Douglas firs pressed up to the edge of the road, swaying and tousling one another. My occasional glimpse of the ocean revealed frosted white tumultuousness.

I pulled into the parking lot and made my way to my special spot on a mini peninsula. The trail raised up to rock cliffs jetting straight out of the ocean. I found my spot where the swells came in, crashing wave on rock, shooting its spray several feet above my head. I felt the mist and imagined myself in the middle of the tumult. I often wished I could be down inside of the water during these storms, feeling its swirling around me, and the force of the rock being slammed into my body. I wanted to fully feel its power.

I find the energy of the earth so enlivening. I never feel it is asking anything of me. It is perfect on its own without me meddling with it. It only knows how to display itself and be. The energy of this helps me to feel free, to just display and be without pressure or expectation. It's a healing salve of permission. Authenticity in its purest form.

When I see the wild, seemingly willful force that nature has, I get the sense that I can perhaps have that freedom too. I can fulfill a fierce and playful role in this world. I do not have to be confined from power, display and creativity. There do not have to be limits to what or how I do things. I can be extravagantly interesting. I can

dismiss many of the rules that I have picked up along the way in life, especially the ones I subscribed to as laws when I was little. I don't have to be small and take up as little space as possible. I am not void of needs. I am important enough to be fulfilled and considered. I don't have to be hidden away, lost in the shadows.

I see my longings as I delight in the crashing of the waves upon my face, partaking of a star blanket and smelling the breath of a whale. I have a longing for the free, wild, and extravagantly gorgeous recognitions of myself mirrored through nature. I am not completely lost; I have nature to reflect patiently for me until I sit still and present enough to accept its wisdom.

Paddle Boarding

MY BROTHER BOUGHT an antique wooden paddle board. It was sort of like a boat without sides and only for one person. I took it down to a beach along the west side of the Island on a sunny, summer day. One of those perfectly glassy calm days when the wind is not even a whisper. The air is resting in her summer respite, turning lackadaisical, as though in a sleep.

I slid the board into the water from the sand and pebbled beach, then dared to dip my toes into that very cold 42° water. The place where winter is always hiding. I quickly jumped onto the board to avoid as much contact with the water as possible. As long as the sun touched my skin, I had the relaxing, comforting feeling of summer.

Behind a narrow beach stands a 300 foot cliff made mostly of compressed sand. Some grasses and vegetation cling to its cliffs and occasionally a straggling tree will brave the crumbling ground. A few trees have slid down to the bottom of the cliff in a pile of sand. Atop the cliff is mostly forest. I am alone in my sanctuary. I let down in the way that I do when I am in the presence of nothing but nature. Its breath gives me excitement for adventure and feeds the deep recesses of my soul.

I lie on my belly and begin the methodic paddling of my arms. Despite the cold splashing and immersion of my arms in the water, the sun rays compensate. I was in the element I was made for. The comforting flow of water, ever changing yet ever there to hold and excite, thrilling with its power and force. This is my spirit element. It treats me like nothing else can. Holding me while letting the contours of my person have exactly the space it needs, always free, always held.

After I had gone down the coast a way, I decided to sit on my board and just be still. I had come to a spot with boulders sticking out of the water. I saw Dungeness crabs crawling along the floor. Cormorants and loons were taking their rest floating on the water's surface. Adam and I had explored this area at low tide. I love how it feels like the door to another planet opening at low

tide. This underwater world exposed in those moments for me to explore. This spot was familiar to me, yet it looked mysterious covered in water, its secrets held beneath.

Below me, I saw a sand shark swimming. It was a reminder of an exciting feeling of danger without the actual threat. I wanted it to keep reminding me of the presence of power, mastery, and authority over a domain. I could sit in its territory and imagine its ripping, shredding power. I felt reassured by it and excited by the possibility of its fierceness. It reminded me that I want to also be fierce and powerful.

I continued my strokes with new vigor as I felt the energy of nature's life force flowing beneath me, invigorated by all of the instincts in nature that seemed to be seeping into me. I held them as precious treasures to carry, to know I am not confined by mental limits. I can be wild and powerful too. I am a creature of this creation. I am complex in my participation and myriad of choices available to me. I am a design, and I am also able to design, orchestrate and maneuver. Do I even realize the fullness in which I get to wildly participate on this earth?

Staying Home

I GRADUATED FROM high school and proceeded to take a summer job at Fort Casey State Park. At the end of the summer mom had another episode with diabetic ketoacidosis. I went to the Coupeville Hospital after a day of work at the park. She was puffed up like a balloon from the flood of IV fluid they were putting into her. Once again, the doctors didn't know how she survived her ketone levels being so high. She was barely coherent. Through slitted eyes, she looked at me and asked, "But what about your birthday, Andrea?" Concern dripped from her voice. I could barely register what she was saying. I couldn't figure how my birthday fit into her almost dying. I was pretty sure birthdays get trumped by life and death situations.

My dad was in the conundrum of being in between jobs. Mom needed full time care at home. I decided to continue working at Ft. Casey while supporting my parents instead of preparing for college. The immediacy of the need over took what I may have been planning for myself. I was pretty content with spending my days outside, tending to the park.

Ft. Casey was built in the late 1800s to protect the entrance to the Puget Sound. There is a long stretch of bunkers to explore, miles of beachfront, and picnic areas in the forest. My job was to walk the grounds, checking on things, picking up trash, and paint the rare ten-inch disappearing guns on display. I loved walking through the dense forest areas as the rain drizzled and brightened all the greens. I loved the fiercely windy days that roused a ruckus in the ocean waters. I loved those rare winter clear days where the sun blared bright on the freshly fallen snow painting the Cascade mountain range.

I felt content during this time. I was able to feel that nothing else mattered besides the simple act of going to work at the park each day. I came home to my parents in the evening exhausted and satisfied. I don't even remember mom being sick except for one night when my parents had to rush to the hospital because she had crossed over to catatonic. It was late in the evening. I was feeling panicked and anxious, so I franticly did laundry to help

calm my nerves. My best friend stopped over because she had heard what was happening. She came in the door, and I leaped into her arms, holding her tightly as my tears flowed. It was one of those moments that I suddenly did not feel alone. I felt embraced and comforted. I am still grateful for the memory of a companion in my sorrow.

Whales and Animal Wisdom

MY DAD AND I sat looking out at the ocean from the second story window of our house. It was a smooth, calm day on the water, a relaxed Spring afternoon. Mom was at the hospital in Coupeville. It was one of those rare times that we felt we could let down and knew she was getting the care she needed and was stable.

We could see the tell-tale signs of the grey whale migrating season from the spray of their spouts not far out in the water. Calmly, my dad said, "Why don't we paddle out to those guys?" I said, "That's right, we should be out there. Why are we here?"

We suited up in wetsuits for the cold Puget Sound waters and drove down to the beach parking lot near our house. The surf boards were strapped to the top of the car. In the water, we paddled south,

down the coastline then a bit west as we headed further out to greater depths. We saw the grey whales spouting from a short distance.

The grey whales do a yearly migration from Mexico to Alaska, covering 12,000 miles round trip. They have the longest known migration of any mammal. Some of them veer fairly far off their west coast path to come east into the Puget Sound through the Straight of Juan De Fuca pass. Every year, we saw them feeding along both sides of the Island. Many years later, my dad found himself a new ocean cliff perch and still watches them today.

As we approached these nearly 40 foot long, 20,000 pound creatures, my heart leapt to new places I had never felt before. It was like being on a wild carnival ride while sitting perfectly still. Bobbing in the water, I could feel the currents from the mass of their bodies swirling under me. A water surge surfaced round and about the size of a kitchen table right next to us. The whale was a few inches from my leg dangling in the water. I'm not even sure if my heart was working anymore. Everything in the universe had paused in the presence of the magnificence of these creatures. The energy of their mass consumed the air and the water around me.

A few minutes later, I felt a surge of current coming straight for me. A large section of barnacle encrusted blubber surfaced as its back arose momentarily then submerged to swim beneath me. I no

longer had breath. I was ecstatic with excitement and fear. I oddly felt terrified, yet safe.

There were two of them, and they were checking out the curious creatures of us floating above them. I felt we could be friends if I could recover my countenance of terror and just embrace the excitement.

The next time, one surfaced parallel to my board, blowhole in full exhale. It smelled like an ancient beach at low tide. I vice gripped my dad's arm with my hand. I had felt the breath of a whale. I carry a piece of awe with me in my heart still. I had been granted the intimate introduction to magnificence and power, curiosity and gentleness.

There are profound truths to be had from our fellow creatures on this Earth. From the eagle, I revere their ability to not be concerned by any other creature. They have this astute confidence. They are unconcerned. Not reckless but confident in their power.

I love how on a cliff, an eagle will pick the most exposed, barren looking branch of a tree, where they are the most visible. They seem disregarding. They are quiet and austere. I get the sense that they are keen to know absolutely everything that is going on without giving a hint of their knowledge. I have seen them hunting. They have mastery in their confidence and abilities. I admire and long for this freedom of confidence.

I have seen the seagulls and crows messing with the eagles surprisingly often. I can't imagine what those lesser birds are thinking. They are so carelessly irreverent. They seem to imagine that their annoying persistence will somehow gain them something from their majesties, the eagles.

I saw an eagle lazily soaring above the bay while the seagulls relentlessly flew around her squawking and pestering. The eagle barely gave them any notice; like they were not even worth her consideration. This went on for about half an hour, when suddenly the eagle flared her talons out and grabbed one of them. It happened in a flash. For the next hour, she sat atop a wood piling in the water, plucking all the feathers out then partaking of her feast. I sat in shock. A little grossed out, but mostly I felt a deep respect for this powerful animal that needed to be respected. Look what happens if one dares to not revere her.

I loved this clarity of power that gave no warning but struck precise and deadly. She is saying with the muscle, feather, and tendon of her body, "Reckon with me." I want to be that flash decisive and clear about my power. Maybe I want to be a little regal, a little aloof while actually aware of what I am capable of and using it in precisely the moment that I want to. Intentional.

Another time Adam and I were walking in the low tide waters along a rock cliff that jutted out from the ocean, raising up to forest.

I spotted a red rock crab walking on the floor beneath the water. He was medium sized. Although I figured it would be pretty painful, I fantasized about feeling the force of him. My curiosity got the better of me, and I placed my pointer finger between its pinchers. At first nothing, then the pressure steadily increased until I was screaming in panic. "Get it off! Get it off!" I yelled, waggling it in the air. My brother tried to help, but there was no releasing that crab unless my finger was going with it. I just had to wait for him to let go which he did in a minute. I completely lost feeling where he had held on. Slowly, lazily, my nerves repaired over the next month.

I liked the reminder of this powerful little creature and that I had an exchange with it in an intimate way. I didn't just know in my head that a crab has a powerful and dangerous pinch. It was no longer an intellectual knowing, it was an intimate, soul-satisfying experience of feeling his place and power on this earth.

Suffering

MY MOM HAD silky, baby smooth skin. Her distinctly blond hair curled along her cheeks. She had a cute little ski jump nose and dimpled chin. Friends told me in high school after a field trip when all our mothers came to pick us up, "Your mom is so beautiful." "Really?" I would say. "Yah. Just look at her compared to all the other moms." As a kid you don't tend to notice your parents. They are not exactly all the way human. I opened my eyes to their view and compared my mom with the other mothers. She was radiant. It was shocking how much she stood out. She was gorgeous physically while beaming from within.

She was beautiful and vibrant in my eyes, but there was also another picture that I was forced to hold of her. This is the one that tor-

ments me; her emaciated, weak, and trembling. She still had smooth childlike skin, yet it was strained and contorted, her body stiff with pain. There would be a distant look in her eyes, unfocused, where she drifted to another land of enduring. There was a lot of vomiting. Lots and lots of vomiting. She was helpless, vulnerable, and at the mercy of her body. All of this comes in clips of horrors for me. It is awkward and halting to express.

I believe I am bridging the stark contrast of beauty, desire, and love with the cruelties of life. I had absolutely transporting times on Whidbey Island. They were full of adventure and play, as well as the deep wisdom of nature mirrored in my interactions with it. This was my grounding to hold tightly to as the trauma of crisis was yet to unfold fully. This is the strange conundrum of my understanding of life. Life can be a space of majesty that can also turn around and cut to the guts of my heart. Life can gnash at me with its cruelty, seemingly unconcerned with anything but destruction.

I wonder at how to approach the telling of the story to give a picture of the long crisis of health we experienced after this. It was like taking in a long, sharp breath and holding it in year after year for decades. We would get through one health crisis and another one would come tumbling after it. The ghosts of a thousand scenes

creep into visibility in bits and flashes. They are entrenched in my brain, yet I am almost too bored to face them. Our normal became a twisted reality as her body continued to malfunction.

Out to Sea

I N OUR YOUNG adulthood, Adam and I took a 27-foot sailboat out to explore the San Juan Islands. This is an archipelago of over one hundred islands in the Puget Sound. The Islands continue spilling up into Canada, dotting the way to fjords. A few of the islands are accessible by ferry or float plane and most, only by private boat. There are tiny private islands, small towns, and state parks. Some islands are about twelve paces wide and can be circumnavigated in a matter of minutes. Some have miles and miles of hiking, lakes, and peaks.

We were young, energetic souls finishing up our careers as teenagers, still having the guile to jump out into adventure first and ask questions later. We didn't have an ending time to this particular venture. It was just about going. We had a pretty rudimentary setup

in our rustic boat. Our water supply was in jugs and the restroom facilities were, you know, a rope hanging over the side of the boat.

We also had a precarious inflatable dingy that deflated the entire time we used it. We'd make sure it was nice and full before we took our ride ashore. We made absolutely sure we brought the air pump along with us because it might not stay afloat the whole way into shore. We, of course, had to fill it back up for the return trip. We were navigating our way to tiny, isolated islands that begged exploring, wanting us to know them and feel their contours.

In classic Northwest style, it drizzled all but one day of our week-long trip and hovered barely above 60°. Our small amount of clothing got wet in the beginning of the trip and remained slightly damp for the rest of our time. I don't recall feeling cold, but then again, none of these little inconveniences could erode our enjoyment in the slightest.

We had been out for about a week drifting from island to island, exploring dense forests, cuddling to stormy, rocky nights, collecting crab, mussels, clams and oysters when we got a call from Dad saying that we better get back immediately. He had taken mom to the hospital. It was precarious enough that he had called my grandparents in South Dakota to come right away.

At that point, Adam and I were pretty deep into the islands. It

was a good six hours if we headed straight back to the marina. We simultaneously pulled up the anchor while starting the motor for the six plus hour trip back. We proceeded with a steely focus, silent and determined. The only words spoken between us came two hours from the marina. Deadpan, Adam said, "Should we stop to get gas? We are getting low." Me, deadpan but with a flutter of intensity, "We can't stop." Because we might not fucking ever see her alive again. Silence. Steely focus. We proceeded without hesitation or flinching except for a little twitch in the corner of our eyes. Resolute focus.

As we approached the marina entrance, the engine quit. Out of gas. We had just enough momentum to drift into the marina and exactly enough left to drift all the way into our slip. Seamless. Neither of us said a word or faltered. The intensity of the moments ticking by were our ever-present driver. As we drifted into the slip, we each glided onto the dock, lines in hand, wrapping them around cleats, specifically unhalting. We found ourselves at the end of the dock unlocking the car and making the one-hour drive along curving roads of the island to the hospital in Coupeville.

I saw my mom in her hospital bed for only a few minutes. I saw her sunken in her body and her eyes. I saw the helplessness cloaked over my dad. He sent me to the airport two hours away in Seattle to pick up my grandparents. I don't remember the drive, except this one

view of a lake and sobbing the whole way. I didn't feel safe. One of many times. One of many, many times. How are we made to endure relentless crises?

A Harsh Decline

I PURSUED LIFE as best I could after that. I stayed home to support my dad in taking care of mom. I took classes at the local community college when the emergencies lightened up for periods of time. I even got to travel to Europe for a temporary job. But after that, I lived at home to help my dad with the full-time care that mom needed after she had a heart valve replacement. One of her valves just wore out. Heart surgery is rather like being bone-gutted in the way that they saw you open. This surgery triggered all of mom's fragile diabetic issues and nerve pain. The recovery process turned into more crisis as her body struggled to function and stay alive. Grandma and grandpa came again when it looked like she wasn't going to make it.

Miraculously, she turned around and was able to start eating again. She had been wearing a backpack attached to an IV for several months so she could stay nourished and hydrated intravenously. My dad also had to give her these weird injections through her IV. He would break the top of this tiny glass vile, then stick the needle in to suck up the liquid. I remember it feeling eerie what we were doing. It was just him and me at home in a strange human experiment. No wonder I feel a terrible lonely weight when it comes to medical situations. This was exactly the same scenario that was happening when I was a child. How familiar it felt.

It wasn't safe to leave mom alone during the long months of her recovery. That was how precarious her health was. My dad and I would take shifts to let each other get out of the house. I never thought anything of being available for this, except for one time that my friends were meeting at one of my favorite oceanfront parks near Deception Pass. I couldn't go because my dad was already out somewhere. It is the only distinct time that I remember feeling like I was sacrificing something to be caretaker for my mother. It gave me a small recognition of the parts of my life I was giving up.

I also had the honor and privilege during periods of respite from crisis to befriend my husband. John and I first encountered one another after a gathering we both attended when I briefly lived in

Texas for a temporary job. We talked until four in the morning. The feeling of talking to an old, familiar friend settled gently and firmly into my chest that night. It was the kind of knowing that is deep and automatic. It says, "I see you, and it feels good and safe to be seen by you."

Early in our friendship, I invited John over for "tear water tea," as he calls it. I did serve him tea but all the tears were on my face. I was feeling disheveled from the disorientation of living in a new place. We had only just met, yet he was the one I sought to pour my heart out to.

I like to say that John and I accidentally fell in love. We had come to know each other as brother and sister. I even had thoughts of being excited about meeting his wife someday. It was a slightly awkward transition to go from a familiar friendship to a romantic one. This has given us a solid foundation. We probably, certainly needed that to help us endure the extreme that we so quickly encountered after we got married. John's relatives very accurately warned him about attaching himself to me and the package of family crisis that I came with. If you ever wanted to have someone stand beside you in the hard times however, it would be John, who is willing to stick with you through anything. He is so loyally ready to dive in wherever he is needed. His generous spirit reminds me so much of my mother.

Within a year of our marriage, my mom went to Minneapolis to get a pancreas and kidney transplant. Another one of the joyful turmoils we had been going through was my mom's slow kidney failure, suspiciously from a medication they put her on after heart surgery. She had been on a pancreas transplant waiting list. When a young man died in a motorcycle accident, his pancreas went to my mother. Adam was in line to give her his kidney.

This transplant surgery was the beginning of what I consider to be a horror show. The chaos that ensued infringed on our sanity precariously. Dan and Lily went to visit my parents in the hospital after the transplant, and they thought that my dad might have dementia. The stress and veracity of my mom's ability to recover and cope with this surgery was astronomical.

Her mind was hallucinating, partly due to medication, but I imagine also from the horrifying amount of pain her nerve damaged body already experienced without the added dump of pain from surgery. My dad was also losing his mind sitting by her side in agony for her.

John and I were covering for Adam's yacht detailing business in Seattle while he was also recovering in Minneapolis from the surgery that took his kidney out. I was only able to go out once to visit them for a few days. The situation was mind-bending. I couldn't take in the magnitude of the desperate space my parents were in. When

they finally got back home to Seattle, we began the almost monthly trips to the Emergency Room.

Transplant patients take immunosuppressant medication so that their bodies won't reject the foreign organ pumping in their body. This allowed her to catch every possible viral and bacterial infection. This also included some strange virus in the transplanted pancreas that was activated by the suppressant medication. Her body had almost no ability to fight things off. Most every time she got a cold, it would turn into pneumonia. Pneumonia often turned into a transfer to the Intensive Care Unit (ICU).

John and I telling my parents that we were pregnant with our first child happened in the hospital. When our first son was born, we took the trip from the labor unit to the ICU unit to introduce my mom to her first grandson. This would be our way of life for the next decade until mom's death. It was this mind-boggling compounding of crisis. The amazing part was how much mom still got to revel completely in her love for her grandchildren. She would lay in bed holding her baby grandson, fully absorbed in his every coo and gesture.

Our life after the transplant was a series of medical crises. Regular life was what we did in between. Our families grew. John and I had two more children. Adam and his wife, Jody had a son.

We worked. Once in a while, we fit in camping, snowshoeing, surfing, or fishing. The blaring scenes of the hospital pronounced themselves dominantly.

WTF

A FEW YEARS down the road after the transplant, my dad had brought my mom to the hospital because she was out of her mind. She would get into these mental states where she would talk nonstop without barely recognizing anyone else around her. She would be stuck in these weird mental obsessions due to chemical imbalances from her health issues as well as from excruciating pain.

This time was unique because she was using the F word nonstop, 24 hours a day, for a week straight. She barely even slept. It was just F this and F that without pause. My sweet, Lutheran mother who would never even be caught cursing a fly, was using this word in every form and way possible. We were all stunned. She sounded so relentlessly crass.

The hardest part, and this has never really stopped ringing in my brain, partly because she said it so many times and partly because it felt so true, her saying resolutely, "We are all fucked. Someone had to say it. God had to say it. We are all fucked." Over and over again she said this. I have a special neuron that was created in my brain from this bizarre experience.

The doctors and nurses kept coming in with mystified looks, saying they had no idea what was going on with her. They had no answers or directional reassurance. We just sat there helplessly listening to the rant about how badly we are all fucked. That's right, mother. I think you have it right. We are so fucked. You said it. You know it. Somebody had to say it.

Guilt

I DID IT wrong. It was my responsibility, and I failed. I sat by my mother's bedside in the hospital once again. For the hundredth time. This time I was sobbing as she lay nearly unconscious. Not out of just sadness so much as a tormenting guilt. I repeated in my head through sobs, "Please forgive me God. Forgive me." I had let my mother stay alive. She told us not to resuscitate her, and I gave my consent for them to intubate her as we stood in the ICU, her gasping for each breath. My instinct for life had kicked in and made the decision.

My brother, sister-in-law, and father had also been in the ICU. But I only saw myself there. The nurse looking me in the face, asking if they should keep her alive. I had been in charge, along with my

family, over my mother's care for how many years now? My whole adult life, I was into my 30s. Why wouldn't I feel responsible? It is what I knew. It was the role I had taken. Loyally standing by my parents' side through chronic illness.

What had we been doing all this time, fighting for her life and so vigilantly watching over her? I was selfish and couldn't let her go. The next day we begged the doctors to take her off life support. They said she would be fine now even though she would most likely have permanent lung damage from the pneumonia. "Just wait till morning," they said.

Now she was waking up in pure agony. The intubation had ravaged her esophagus. She was awakening to an even greater misery than her already physically tormented existence had been. It was all my fault. I let it happen. Why did I take on the burden of this responsibility? I hear stories of other people doing the same thing, carrying this heavy weight of responsibility that we don't even have control over.

I believe that since I was a little girl, I had dedicated myself to making sure that my mother was okay. I did not realize what I had taken on. It was so automatic for me to loyally serve. Unnaturally, I had reversed some of the roles of caretaker before I was even 12 years old. I gave up some of my innocence and childhood. In health,

my mother was still amazing and nurturing to me. She poured love into me every way she was capable. She advocated for me.

I have come to see that some of my innocence got dashed as a little girl. I had to hide, protect, and diminish parts of myself so that I could carry that burden. I continued to carry that burden in the circumstances that came into my adulthood as she continued to decline. The role I had taken confirmed.

It is no wonder I am just now learning to call myself out and put myself back into the equation of life and taking up space. No wonder I have this strong desire to be feral and willful and wildly partake of life. No wonder I am so exhausted. Exhausted from suppressing myself into the deepest recesses of my heart. I am calling and coaxing those parts back out now. I am leaving quiet spaces open that are soft, tender, inviting, and gently beautiful to see what will arise and feel safe enough to come.

I can look back now and recognize how I took on the burden of so much. I do it with my kids even now. I'm working to detangle from that story. I can, however, look back and be proud of myself for standing by my mother's bedside and supporting my father. Good for me that I loved and was willing to sacrifice. I have learned a tremendous lesson. I love the integrity and thoughtfulness I see in myself for this. These are the parts of the story that I want to take and hold dear.

A Connection to Mom

I SAT IN the chair kitty corner to my mom laying in her hospital bed. The room was full of my family taking up all the sitting spaces. Mom was babbling. The words she strung together couldn't put themselves together in meaning. Everyone sat quietly. There was no use in trying to communicate. Coherence was not with us this time around. My anxiety was flowing out of my fingers into the knitting needles I was furiously clicking. The yarn was weaving together, the one thousand tender, raw emotions I was holding for my mother, for this situation, and for myself. My confusion meshed together in pattern that made comforting sense.

Mom began to do something funny with her hands. She had stopped talking, her hands tilting back and forth, fingers trilling in

the air. I saw her eyes shifting between my hands and my eyes. She had a concerted look aimed towards me. I felt this invisible thread of connection. She was connecting with me the only way she could figure out in her confused mental state. Wordlessly, we found a deeper communication. In the chaos of the situation, I felt comforted by her reaching to me. It felt important and vital to both of us. Amidst the bizarre consuming of her health, we still got to feel connected.

Some of the hardest times for me were the long spells of mom being incoherent, delusional, and catatonic. I would feel starved for her person, the energy of her essence. I would be so grateful when she would come back to us, her mind set aright. I would wait, knowing that something profound was being taken away. I wanted my mom back. What was this unseen competitor that was taking away my precious mother? It was blocking the treasures of our relationship, our time here on earth.

In that moment of my mom's brain in disfunction, we found something pure and true to cling to. Our souls in a union of understanding that we were here, in this place, together. No matter how tumultuous. When she came out of that state, back into her functioning mind, she didn't remember any of the things she said or did. The one thing she distinctly expressed was that she felt keenly connected to me. The power of that deeper soul connection stuck in

her subconscious. She felt the form and shape of it inside of her. That kind of communing is something I thrive on. Its substance invites and nourishes. I imagine that is the connection we will carry with us through eternity.

Topside and Downside

I'VE BEEN A part of death. My hands were seeped in and up to my neck in it. I tried to protect myself, but it took and dragged me down with its teeth and its cruelty. I'm too sensitive for this life perhaps. Or maybe I'm just human. I built walls for my protection until I found myself caged and isolated.

I was 34 years old by now. My mom was constantly in and out of the hospital. I had tapered off taking shifts to help take care of her after the birth of my third son. The compounding devastation I felt about my mother and the confusion of my hormones left me in a complicated postpartum depression. My resources of holding it together were abandoning me.

Depression is a cruel animal. It takes everything you once loved

about life and sucks all the flavor out of it. You're asked to continue your days as though each simple moment, every mundane decision, is not exhausting you to the bones. "Remember to breathe." You may tell yourself. "Just breathe. I'm used to it by now. Staring at the ceiling. Just believe." This is from a song by Telepopmusik. The first time I heard this, it melted me with recognition. It was a serenade to the state I was in.

I remember the precise moment I fell off that cliff of depression and despondency. I was a mother at the peak of her demandedness. I had a newborn strapped to my chest, a toddler with big, bright brown eyes, and a kindergartener who was articulately concentrating on the insect world. At that phase of motherhood, nothing really felt like my own. My own body didn't feel like my own as it was used to provide nourishment for my baby. My toddler kept a tight radius around my legs, and there was a generous need for butt wiping and mouth feeding all day long.

I was already exhausted deep within my soul from the trauma of my mother's health. I had already been standing on a precipice. My friend, out of desperation, asked me to watch her toddler since her babysitter had crapped out. Under my care, her son ran around my yard needing constant supervision, unwilling to listen to my directions.

It was this moment of almost resolute helplessness, that the last drops of my internal resources evaporated. I felt so clear suddenly. "I can't do this. I can't do any of this." I stopped. In my mind, I could actually see myself at the edge of this seemingly endless cliff one moment, and the next moment I was calmly falling down and down and down. It was my last moment topside.

With no effort, the wisp of a breeze had pushed me over in slow motion. I knew clearly that I had fallen into another space in this life. Like entering the pocket of a different realm. It was dark and unfamiliar. I just sat quietly, not seeing anything, not knowing anything. All my senses seemed to have left me. All of the rules had changed. From then on, it felt like I was in this strange daze, not really here or there or anywhere. Like my soul had gone into dark shadow. I just sat, quietly staring, unblinking, unknowing.

I continued through my days after that robotically, sometimes in a trance, and sometimes panic would overtake me. I somehow managed to be fueled by a nurturing energy that overrode my emotional paralysis. It gave me a continued stamina to devote myself as a mother.

By then, I had watched my mother suffer on and off for 25 years. The last decade, while I had gotten married and started my own family, had been torturous. I had a faithful and loyal partner to join

me in this battle. There were monthly ER visits. Most holidays were spent at the hospital. We all felt like The University of Washington Hospital was our second home. I would think of it with a twisted familiarity.

Before having kids, I would take the long walk from my apartment in Fremont, along the canal, the marinas, the docks, the boats, and those towering Northwest Evergreens, to spend time with my mom at the hospital. I got to mix this wild, spacious, sensual, and invigorating experience with time spent sitting by my mother's side in a space of agony. I was getting to see this other peaceful, serene side of life that wanted to give and fill up, to nurture instead of take, like many of the cruelties in life I was witnessing.

After having kids, I felt so helpless in being there for my mother. There was only so much I could take and stuff down inside myself without processing it. I was so stoic through most of it. I just took it and took it, handling and supporting each situation. I look back now and wish I had taken time to grieve all those moments as they came. I thought I had to be tough and handle everything.

When I turned 40, my mother had been gone several years. I found myself still battling depression and now staring up at a mountain of sorrow. The air was dark all around. I was standing at the very base of this dirty, dingy mountain shadowing me. Looking up, I felt

like a little girl, wondering, "WTF am I supposed to do with all of this shit?!" I didn't even know how to approach it. I was, however, grateful that I had even discovered this mountain of sorrow. Before that, it had been this obscure, daunting shadow I always felt. Like a big thumb, always pressing down on me mixed with an ever-present choking feeling. It was exhausting to carry.

So, there I stood at the base of the mountain. I was still at the bottom of that dark pit I had fallen into a decade previously. Everything was bleak. I did feel a bit of courage though. I started to see the possibility of new life. I had discovered a spot of hope in watching seeds sprout in my garden. I was desperate to have any glimpse of beauty. I longed for a sliver of joy. Both felt so distant and elusive. I figured out that if I got myself into the garden and just toiled around in the soil, something felt familiar. Something felt real and tangible. I made a connection to the earth that was much like me. It held the same ingredients. It was a menagerie of sodden, crumbling things festering in the dark. Transforming and preparing without light turning into something to nourish. Mulching, folding, and transforming. I love that sweet smell of earth, that gritty feel between my fingers, the dirt pressed into my fingernails. All the pain and strain of being alive melted away in those moments, and it felt okay to be alive, good even - like a little spark of delight had fluttered my way.

I started planting seeds every day at that time. Those first, new sprouts gave me a spark. The hope of possibility alighted miraculously and self-contained.

Driving Away

J OHN AND I endured another two years of raising our young family and assisting where we could in the endless assaults of health crisis. John went to a few sessions with a therapist and got the first inklings of the idea that he was allowed to take care of himself and his side of the coin.

He had unquestioningly moved to Seattle when we got married to be near my family. He had enjoyed so much of what the Northwest had to offer. He did have to endure the cold soggy weather in contrast to the tropical weather he had grown up in. His heart was longing to be near the family and friends of his own history in Texas. It would take a lot of courage to give ourselves permission to make a choice just for us as we contemplated moving to John's territory in Texas.

My husband, three little boys, and two pet mice were strapped securely into the car. In the salty parking lot of the marina, cool ocean air dusted the hairs of our arms. The smell of asphalt mixed with low tide. The engine revved, warmed and ready. The small crowd sat and stood with arms reluctantly waving to the family abandoning the crisis, the pain, the trauma. They were all secretly happy for us, that we got to escape to experience something different than doctors, hospital beds, IVs, and pain.

We had decided to move to Fort Worth, Texas, the place of my husband's family of origin, and where our college friends had settled. My husband had a deep longing to be with his people. He had uncomplainingly stood by my family's side the past ten years. I was desperate to not see my mom suffer anymore.

I saw my mom sitting in her wheelchair, her kidneys failing, blindness setting in, and the constant nerve pain exponentially increased by her broken hip. I had seen my mom in lots of different kinds and degrees of pain. Her current condition vastly surpassed everything previous. I could honestly say that I was desperately relieved to be driving away. I didn't know how to look anymore. It hurt so bad to watch her writhing in agony. Her mind struggled to stay coherent under such degrading conditions.

It was unthinkable for me to even consider leaving her and my

family's sides, when things were so desperate. My very nerve endings were used up in the constant crises of it. I didn't feel sorrow or sadness in leaving. I felt relieved. It was the only way I had ever allowed myself to take a break from the vigilant watch. I still picture my mother's smile through her contorted face as she sat in her wheelchair, grimacing through her insides burning up in pain. Something in me had shut down, and I couldn't look any more.

My sister-in-law, Jody, proceeded to give us the finger as we drove away. We had a joke going about who was the sucker and who was the fucker. They were the suckers for getting left behind, and we were the fuckers for leaving. In loving and longing, we all wanted to escape. We all felt relieved that at least some of us could have a break.

When I had months earlier been torn about making the decision to leave, Jody was the one to boldly ask what it was that my husband and my family needed. Shouldn't I be considering my husband before my family of origin? She selflessly gave me permission to put our needs first. I hadn't realized I could do that. My parents had been my first priority most of my adult life, with good reason - because of the brutal reality of the situation. She was wise and insightful enough to point out the importance *of us* for us and of what we needed. She did this even though that meant it would

put a vast distance between us and them, leaving them to witness and support alone.

The suffering was so gruesome to watch. I don't know how to describe the wall of toughness I had to put up to see my dear sweet, loving mother who was still such an amazing and loving friend to me. To watch her in pain 24 hours a day, always on the verge of throwing up, always pushing past the excruciating.

What the fuck??? That did become my motto for a long time. I didn't know how to contend with it. When she died, I felt like an obliterated, wasted human being left on the side of the road. I didn't understand the point of it all. You suffer, suffer, suffer, then die a really painful death. I watched her skeleton body in its last torments. I felt abandoned. I had stood by and fought and watched and sacrificed only to lose the one I loved so deeply. I had become the loser of life. What the fuck was the point? "Someone had to say it. God had to say it. We are all fucked." From the lips of my own mother, I cling.

As we rolled down the road, relief washed over me. Something was different. Different was good. The best part was that we had a lazy, lackadaisical drive ahead of us down the West Coast. In high school, I had dreamed of walking the west coast by myself, thanks to the inspiration of Peter Jenkins who had walked across the United States. I thought that sounded like the most wonderful idea in the

world. Carefree with nothing above me but the sky, nothing pressing or pressuring me except the feel of the ground below my feet. My most heightened senses coming from the breezes mixed with winter storms of waves and rain, moss, fern and spruce. I wanted to get all mixed up in those ocean storms, churned and frothed in an endless force of power reflected in water through wind.

Now I was doing it in a different form. We could take as much or as little time as we wanted. Nothing was holding or calling us. My husband didn't have a new job yet. There was no home waiting for us to occupy and calling us to the duties of daily life. Everything was new and fresh for our taking. We drove for no more than three hours a day, sometimes stopping for multiple nights in one spot. It took us weeks to get along the coast, which is already the long cut to Texas.

Our first stop was the Oregon coast. Growing up, we used to take yearly trips there. I was always fascinated by the big tidepools with vibrantly textured creatures. The towering sand dunes that I would climb up and let my body cascade down in big, flying leaps while surrendering to that suspended moment of freedom.

We found a little camping spot tucked in a forest next to a sand cliff. The Oregon dunes can feel like being in the desert but always with a damp cool breeze. They are often slightly hazy with fog. They seem so mysterious yet attainable to me. I imagine myself tucking

into their tall grasses like a mouse and living there. Waking up to the mist and sound of the ocean every morning was an invitation to be alive. Behind our campsite was a steep sand trail that led up into the dunes. At the top were towering hills of sand rolling up and down, grasses and shrubs between short, mangled pines and bearberry bushes. They are the kind of trees that have gotten tangled intimately with weather. They are the storytellers of weather's history; that gives witness with each of their twists and turns that have formed over centuries. They are majestic and royal to me. The towering, wise voices of the elders that I can sit before and behold, rubbing my hand along their branches, feeling the magnitude of their lives. I could never take enough time to hear all the whispers of their stories. Looking across the distance of rolling sand, I saw the ocean and its white crumbling coast of driftwood. I stopped myself from leaving my family to drift out to its waters and commence a life in discovery of its mystical powers.

Last Birthday

I GOT TO spend my mother's last birthday with her. My youngest son, who had just turned three, and I flew to Seattle to celebrate. It was one year after we had moved to Texas. My mother's birthday is on Halloween, which she always hated. I have no memory of her birthday growing up. I just remember the excitement of getting dressed in costume and that bucket full of candy.

This year we ignored Halloween. My brother and I went to Trader Joe's together and filled up our cart for a feast. Does one get a premonition about the importance of a thing? I think so. It felt so sweet to be working together with my brother again. We both filled up our basket vigorously and with abandon for this one last feast to celebrate the sweetest of mothers.

My mom was not in good shape at this point. She had been on dialysis for the last few months which should be recognized as the life support that it is. The extreme measure of flushing fresh blood through a person's body nearly every day in order to keep them alive is kind of insanity. Her body would often react to the foreign blood. They also kept her partially dehydrated for the treatments, which significantly increased her nerve pain and also messed with her body chemistry and mental clarity.

She was so present for this birthday trip though. I don't know how she had the ability to muster up complete and total clarity to be present for the occasion. All that she had to fight past to be present. Why did she do it? Why did she bother? Because she loved us, and she wanted to be with us. I think that her whole will to stay alive was connected deeply to us. It was her tremendous depth of desire to generously sacrifice.

My parents lived on a 44-foot sailboat at Shilshole Bay Marina in Seattle. It had given them the opportunity to be surrounded by nature and adventure despite the confines of health issues. I had a moment alone with my mother in her room at the stern of the boat. She told me, "I don't know if I can keep going Andrea." "Mom you don't have to keep going. You can be done. It's okay to be done." "But I don't want to leave you guys. And what about

your dad. Will you guys take care of him?" She asked.

I think she felt responsible to keep going for us, especially for dad. She didn't know how to be willing to leave him no matter what it was costing her. But her body was shutting down. Her willpower alone was no longer enough. There wasn't much left of her body's ability to function. "You get to be done mom. I love you." I was able to give her permission to die and tell her how much I loved her. She was dead almost exactly a month later.

My Death Garden

IN THE EARLY Fall of 2013, before I had gone to my mom's last birthday visit, I had planted a winter garden. My plot was full of lettuce, chard, kale and garlic; all things that could handle a milder southern climate. I was just discovering the joys of having six growing seasons to choose from as I had only ever lived in the North before this. I had a big back yard filled with spaces for growing. I had come a long way from my Seattle condo, gardening in pots on my balcony.

I went to my mother's birthday celebration in Seattle and came back to my garden which was well on its way. My seeds had sprouted, already on their way in their young new life and grown into mini, recognizable versions of themselves, still tender yet gaining strength.

They had that look of deep winter green, the kind that holds fast to its nutrients. I felt good and settled that I had my garden under way. They were getting a nice start before the cold season set in with possible frost.

I talked to mom on the phone every day after I got back from her birthday and heard her slipping. Each day that I talked to her she was a little farther away. In between nonsense, she would ask me to tell her again how she had taken care of me when I was sick with chickenpox as a child. I always remember being so comforted by her. She wanted to know that her job here on earth had been well done.

By the end of the week, she was just babbling incoherently, not able to hear or respond to anything I said. I had taken a call from her right before a yoga class while she was in this state. I hung up the phone with a blank, dazed look. I felt nothing. I felt a wall. My friend told me, "Wow, you are handling this really well." It took me a long time to realize that I was not handling it at all. I was in such a numb shock that I couldn't even feel anything. Did I want to live in a state where handling something is being void of emotions?

It was a couple days later that I got the call from my dad, "Your mother is refusing to go to dialysis. She is out of her mind and incoherent. You better come right away. She is not going to make it very long." I flew out the next day. I sat by my mother's bedside for the

last weeks of her life, watching her incoherent and writhing, moaning in pain. I tried bringing the dose of morphine to her lips, for possible relief but she refused in agitation. I felt helpless watching her naked skeleton of a body be carried by my father back and forth to the bathroom, one of the side effects of kidney failure. It felt like this bottomless pit of suffering at the end of a long, long nightmare.

Finally, we took her to hospice where they gave her something to knock her out. It still took days until she would leave this earth. I have never prayed so hard for death. I ached for her release. She was finally able to let go when we gave in and went out to get some food at a restaurant. We had so vigilantly stayed by her side, inadvertently inducing her to keep going I suppose.

We got the call from hospice while we were sitting down and mid bite at our table. Instead of rushing out as I was anxious to do, my dad took his time to pay the bill. I was baffled. Your wife is dying, why are you paying the bill so casually? When we got there, we had missed her passing by a matter of minutes. It was just her warm body left.

I stroked her hair with my last goodbyes. That generous, blooming glow once on her full and healthy face, her still smooth, beautiful skin, her gorgeous blond hair. The hair I stroked now, while she was still warm, clinging to the last touches of warmth and energy she

held here on this Earth. The space she took up dissolved into something mysterious and stark.

The bells sounded from the ceiling, faint yet distinct, in celebration of her arrival to the beyond. That welcome spirit embraced with a revering honor. The nurse commented on the bells because they were so unusual. She had never heard that sound before. They were the bells of heaven welcoming this glorious and faithful creature.

I was so relieved and grateful that she was given respite from the excruciating torment of this life. But I didn't really know how to live without my mother. I was crushed. My whole idea of life was obliterated. I longed for her to be done here after a lifetime of suffering. But I forgot what it would mean for me to lose that constant warm whisper of encouragement and advocacy that she was to me. That best friend that loved me to the core. I sat slumped in the rubble of my foundation. When I looked up to the sky, I saw a visible crack the shape of fat lightning.

There were no more glimpses of life being this sweet, loving or safe place. I should have already realized that after all the suffering I had watched. Somehow, I held onto this blind faith that everything could still be okay. Losing my mother was the grenade to all those pretentions. It's not okay. Suffering, suffering, suffering death. What just happened? A crack in the universe.

All bets were off after my mother died. The floodgates opened. The reckoning. I began to let down after the decades of crises. I lay on my mat after an exercise class and began to cry. The sobbing created a lead-like effect, almost a partial paralysis. My limbs had no energy or movement to them. They were helplessly weighted to the ground. My friend had to drag me off my mat and partially carry me to the locker room where I could finish it out.

There I was, crumpled to the ground. Fallen in a pile of leaves, sobbing deep and hysterical. On the floor after yoga class, sobbing, unable to rise. In the line at the store hyperventilating, tears and panic, eyes staring. I saw them looking uncomfortable and sorry for me. They didn't know that the world had cracked.

I spent a month in Seattle for my mother's passing. I hardly knew I had a home in Fort Worth. The time consumed me, body and soul. Nothing else in the entire world felt relevant except that my mother had ceased to exist. I would have to work really hard to find any nuggets of grounding. I was like the cliffside bonsai that had weathered the storm through history, endured and stayed firmly in the ground. Then an earthquake came and the ground shifted, the roots seized up. The love that had been holding it firmly to the ground had vanished. A mother's love. The love I had stood by so loyally, completely and suddenly vanished. What was

left? What was it all for? I would have to lay on the ground and cry for a year. Facing each day wet faced. Telling my feet to move forward for my three young children. I couldn't fall completely into despondency. My love for them kept me threaded to life by a strand.

Unfortunately, I had already discovered that alcohol can help when life feels excruciatingly like too much. I would try to take the pulsing of that deep, deep ache for as long as I could. Until everything in me screamed for a reprieve. A break from the endless pit of despair was only a few sips away. Once I started feeling that respite, it was really hard to go back to feeling the hard. I just wanted to stay in that beautiful light feeling forever. Where suddenly everything doesn't matter so much, the heaviness of life lightened.

The only problem is that it is a rouse. A trick of the play. I would wake up the next morning feeling even shittier and even more tired as my body processed the toxins. It would scream even louder for a break, and the cycle continued. It sucked away what little energy I didn't have. I remember thinking that I didn't know how I was expected to feel this deep of an ache. This unresolved tormented feeling. I didn't know how God expected me to take it, to handle it. I figured that must be why he made alcohol. That was my twisted, grief-stricken brain using its logic.

The night my mom died we went to my friend Heather's house where we were all staying. Heather was a long-time friend of the family. She felt like a sister to me. We had done a symbolic signing of papers ceremony to adopt her in. My dad, my brother, his wife and son, my husband and three young boys were all there. It felt like being home.

For some reason, we started drinking screw drivers. I presume because that was what happened to be on hand. We sat in shock, disbelief, and an otherworldly state of just drinking and drinking. My dad got a call from the organ donor people asking him all these detailed questions. "Excuse me sir, tell me about your wife's eyes before we cut them out. Can you elaborate a bit more on the condition of her skin? How about her organs?" That's the kind of shit you have to deal with right after your wife dies. It's this bizarre oxymoron of life. Fortunately, we had a lot of screwdrivers to compensate for that.

Oddly, we were all talking and laughing. It was all too hard to comprehend. "I'm glad she's dead," said my dad. Relieved at the liberation from her painful existence on this Earth. He was joking about telling his brother this, and we were all hysterically laughing, except for Jody who was shifting uncomfortably. "Um. I'm feeling not a little disconcerted about this picture of you all joking and laughing. Your mom and wife just died a few hours ago. Did I miss

something?" She asked. "Well, it's better than crying." We all chimed in tipsy voiced. It was only a matter of minutes before we were all sobbing. It was probably after that organ donor person called.

Still to this day, I pour myself a screwdriver on the anniversary of my mother's death to commemorate that night. That transcendent night where everything shifted. Where we gathered together in a spiritual space while still being held in our bodies. We were lifting with the tip toes of our spirits to get a peek at having some kind of knowing about what just happened and to get a glimpse at what was on the other side.

It was exactly three in the morning that night when I woke up and found myself firmly fashioned into my existence of a very human body. It was the full force of realization that the nightmare of loss became real. I got out of bed quickly and wandered into the living room where the deepest, most guttural sobs overtook me. I cried like that for five hours straight. Heather woke up first to find me. I saw the intensity of compassion in her eyes as she simply said, "Oh Andrea." And held me.

It was this tremendous, crushing realization that nothing was right and that the world around me had cracked. Space and time also became this abstraction that didn't fit into my reality anymore. I was seeing the world around me without seeing it, or being in it, almost like an illusion.

I had stayed for a couple of weeks to help my dad and brother take care of affairs after mom died. Upon returning home to Texas, my husband picked me up at the airport. On the way driving home, there were big, fat chunks and sheets of ice on the road. They had been having ice storms.

As I always do when I first get back from a trip, I headed straight back to my garden. The garden I had planted before my mom's birthday. For some reason, I delight in seeing what is happening there. What life has occurred while I have been gone? All my beautiful plants were encased in a thick layer of ice. "That's perfect," I thought. "All is lost. All is truly lost." It was the crumpled end of everything.

Things thawed out and warmed up as they always do here in a Southern winter. I only had the anticipation of death and destruction for my sweet plants, so when I went out to the warm air a few days later, I was completely surprised to find a thriving, vibrant garden. It felt like a promise of hope.

I would spend the next year in devastation, but I had that promise of hope to hold as a flicker in my heart. Not all had been lost. There was a promise of something new, of life. The harsh and brutal can come, and there can still be life left over to continue after. I clung to the encouragement of those leaves as they grew and flourished,

giving me a glimpse of possibility that I would need to figure out how to plant new seeds for my own life to move forward once again.

The reality of having to force myself forward hit hard when I got back home. Everything around me was moving so fast. I couldn't even process a millisecond of it. Someone would ask me a question and I could barely pull myself out of the deep recess I had fallen into to hear their voice, much less register what they were saying.

Christmas came quickly as her death was the day after Thanksgiving. I don't even remember that Christmas. I just sat there blankly, unable to process. I went out to look at the sky to feel some sense of orientation, and I could physically see that fat, jagged crack across the sky. "That's right," I said to myself. "That makes sense. The actual Earth has cracked." Now I feel a little more oriented.

The one thing I did find relief in was folding these little origami balls. I just kept folding them over and over again. Everyone got an origami ball for Christmas that year. The comfort of the monotony of something real, tangible, knowable, and feelable. I could focus in on understanding each fold. I had lost the ability to know anything else about life. When I did begin to be able to think about life again, my conclusions were not pretty. The one good thing was that I did not give up. I continued to press forward in any small way I could figure. Minute by minute if that was how I had to do it.

The Road of Grieving

AFTER MY MOTHER died, I woke up every morning with hot tears before I had even opened my eyes. I would wake each morning to understanding if I had just had a nightmare or if it was real that my mother was dead. I would work it out and learn the truth afresh each day. I dreamt of death most nights. It was always someone dying, my mom dying all over again, or just the decay of death. All I knew was death, decimation, and rotting destruction. Every sleeping or waking hour of my life for that year felt like a torment. Tears flowed through every single one of my days.

I hate to think of what my children experienced over that time. There is mom sitting at the dinner table crying again. Mostly, no one said anything. They just quietly let me do it because it was ever pres-

ent. Death and grief must feel very intimate to them as such close witnesses of it. Were they terrified? Did they accept their mother's sorrow? Did they feel compassion or anger? Was I pouring enough love into them from some hidden recesses of myself? They will find out later in therapy, I suppose.

It's painful to think of how that time has affected them. Then I remember that there is redemption. Things can be redeemed. We can take ownership of our stories. We get to claim exactly what we want to claim. I do see this softness and compassion in my kids. They have intimately grazed death, and they hold a place for that kind of sorrow. Their last memory of their grandmother is of her squeezing each one of them with all of what remained of her withering strength. She poured into them this boundless, powerful love. Without words, it poured out of her every cell. I ache with longing for them to have had a longer time with her. My youngest son was three when she died. Yet, I see how she imprinted this generous love into them. As my oldest son used to say when he was little while hugging, "I'm pouring love into you." My mother was the master of that. It didn't matter how much pain she was in or how hard it was to get her brain to focus coherently. She read to her grandchildren, played Kings Corner, checkers, and did activity books. She loved taking the time to teach them letters, shapes, and colors. She met them with the fullness of herself.

Hiding Grief

Something I really did not know how to do was to let others in on my grief process. I didn't know how to let others witness my grief in order to find validation to my experience. I didn't understand how I got to feel and be seen. I spent a year crying every day throughout the day. I would be hanging with friends and feel the grief springing up in its endless waves of intensity. I walked out to the bathroom or stepped outside to have it out, then return to the group. It was such an isolating experience because my whole life for that period was permeated with the grappling of loss and lamentation, and I didn't share it.

I was starving for validation of my experience, so I joined a grief group. I barely said anything there, but I did listen and gobbled up

everything that was shared. I put it in my box of clues to piece together how to understand my hidden experience.

I had become so used to being tough and hard and putting my needs in the absolute last place, and inadvertently making myself invisible. In fact, I think my needs were even lower than that. I think they were not even on the board of consideration. I was tormented with not knowing how to account for the intensity of my devastation.

My husband tried taking me to several counselors. Surprisingly, a lot of counselors like to do a lot of their own talking and sharing of anecdotes and not a lot of deeper listening. I would often feel anti-validated after a session until I found a therapist that delves more into depth psychology. I am a deeply feeling and perceiving person, so the depth of my grief and conclusions matched that.

My grief group told me to write a letter to my friends to share with them what I was experiencing because there was no way for them to know what I was feeling. The grief process very much involves living on another planet. I became an alien to the Earth where all the laws of physics were altered. Time and gravity don't work the same. Actually, I went into a time warp where time pauses. The only trouble is, I could see Earth time still rushing along as usual around me. That would have been a great thing to share with my friends.

"Hey guys. I am so deep in sorrow that time has stopped for me. I can see things rushing along around me, but I can't make sense of it. I wake up every morning trying to figure out if the nightmare that my mother died is real or a dream. Before I open my eyes, I figure out it is real and the tears stream onto my pillow. That is how I greet each day, with a deep, gut wrenching sorrow. I can't eat because it feels like acid is regularly dumping into my stomach. I basically cry myself through each day and often find myself sitting on the couch staring at the opposite wall, exhausted and blank, just reminding myself to breathe. And when you stop over and find me crumpled on the floor crying, all I need is for you to hold me and be in my presence as I process out this unbelievable ache."

I kind of fantasize about going through the next death in the family. Not morbidly but because I want another chance to do this grief thing right. I want to give myself the freedom to tear my clothes, gnash my teeth, and wear sackcloth and ash, and fall onto my knees in the middle of the street wailing.

I don't want to have to act like the world has not cracked and pretend to keep going, feeling like I should be participating just like everyone else in this obscure life that doesn't make sense anymore. I want to shout it to the world so I can give proper homage to the depth at which I am devastated to go on living even a single day

without my mother in my life. I want to recognize the depth of connection that person was entwined with me on this Earth. The tendrils of their life ripped from my veins and the agony of uprooting from this Earth life.

I wondered for so long where my mother had gone. I would whisper into the air, "Where did you go, mom? I don't understand where you went. I had felt so connected to you with the core of me. Then this mysterious disappearance?" I became keenly aware of this invisible barrier between heaven and earth that is utterly impenetrable. Once in a rare while, a bird that came singing near me would sound like my mother's presence. I treasure those moments.

John and I were driving in the car together the first time we heard the song "Heaven" by Los Lonely Boys. We both heaved deep sobs then and every time after we heard it.

How far is Heaven?

Death Aftermath

I SUPPOSE I let down for the first time after my mom died. I re-member the realization that I could turn my phone off at night after a decade of being on call. There could be no more calls of crises. I'm taking your mother to the ER. She's not quite breath-ing. She can't eat. She's not talking right. She's incoherent. Her blood sugar is sky high. She has collapsed. I can't get her to re-spond or wake up. Her mind is not right. Call your grandparents, they better come right away. Call your mom's sister, we need her help. Her heart stopped working. Her kidney is quitting. Her colon is blocked. She has pneumonia. She is delirious with fever again. She may have had a stroke. We are not sure she is going to make it, you better come.

I guess one would become numb to crises in this case. It just normalizes this heightened state of being in trauma all the time. I'm pretty sure I have adrenal fatigue after all that. My symptoms of fatigue, muscle weakness, exhaustion, anxiety, frequent illness, difficulty sleeping, etc. indicate as much. Adrenal fatigue develops when the adrenal glands are stressed and cannot produce the necessary amount of hormones required to keep the body functioning normally.

What is it like to spend decades watching your mother suffer? What does that do to your sense of normal? What does that experience tell you about life? How do you find a sense of hope, reality, gratitude, faith, joy, or possibility? We are not made for constant stimulation. How does our adrenaline work? I found quiet spaces to recharge.

I didn't understand the need for letting myself step away from the crises. That I didn't have to dutifully drive myself into the ground. To know that I am valuable and deserve respite. I got lost in the single-minded focus that my whole aim in life was to take care of others. This was all heightened by the sense of urgency for keeping a life alive. I either forgot, or I never quite knew, that the whole of me is utterly important and valuable. There was so much more to me than just caring for others, my parents, and my

children. Not recognizing that was exhausting. I don't even know what energy I was living off of. A sheer sense of duty I suppose? The truly sincere love I had imbedded in me? The fumes of that love and duty kept me going in the essentials, but the mental energy for a sense of myself was fading. Even just the mental and emotional capacity to manage basic life was leaving me. I was in the conundrum of crumbling and misfiring of my brain.

We are so resilient and malleable as human beings. We can really take it and take it and still recover. Our bodies mend and adapt. It compensates and protects. When panic and anxiety started to run rampant inside of me, my body was telling me that it had run to the end of its capacity. My body was saying, "I need a refuel man. I can't just keep putting out in this heightened state. I'm running ragged and frayed at the ends."

I also had a tremendous storage dump of unprocessed emotions from every time I saw my mom writhing in pain and didn't lament in some space or form to release that energy of sorrow. To give credence to it not being right. The innocent suffering and pain. It's not right. I get to claim that. I stored up those horrible feelings. I pocketed it in a thousand little pebbles of sorrow and tucked them into the shadow of my heart. Still festering and oozing there, volcanic.

I don't have to be happy and accepting of all the awful things happening. I get to call it like it is. Not dancing around the hard, pretending that it's not there. I'm picking up the stones of hard, holding them in my hands and seeing them, really seeing them. Feeling their surface and letting my soul mourn something lost that they represent.

Relentless Suffering and Northern Pikes

THERE IS A famous study from the 1970s about the behavior of the northern pike. This is naturally an aggressive fish, a real go getter. In the experiment, they put pikes in an aquarium and feed them minnows. The pikes, with brilliant determination, eat up the minnows decisively. They are clear and precise about their meals, their nourishment.

Then a pane of glass is placed in the middle of the aquarium. The pikes are on one side and the minnows are released on the other side of the glass. The pikes immediately dart at the minnows, bashing themselves upon the glass multiple times. They attack and attack at first, then begin to go after the minnows more timidly, cautious, and with less force. They are learning the futility of their efforts. The

hunger loosens its grip on their instincts, and they eventually give up altogether, resigned to their fate of helplessness.

The pane of glass is removed after a time and the minnows swim freely among the pikes. The pikes completely ignore the minnows. They have learned to not even regard their presence. Their experience has drilled into them their helplessness, and they have learned the futility of their efforts. They are blocked from their instincts, the purposeful drive of their needs, and their hunger. They have lost any sense of possibility, even when it is swimming right in front of them. They go on to die of starvation.

The futility of my efforts to help my mom feel better and stay alive had loosened the grip on my instincts for joy, beauty, and purpose. Nothing I do matters. Why try? We are all fucked anyway.

I was given a really different lot in life. It was a long span of enduring. It was sacrificing a lot. Giving up on my own journey to care for the life of another. To survive. It was tormenting to watch so much suffering. Innocent, incoherent suffering. It would happen in so many cruel, unusual, and varying ways. Besides the burning daily pain from her neurological disorder, her heart valve stopped working, she had heart surgery, bladder infections, kidney failure, diabetes, pancreas and kidney transplant, and constant life-threatening sickness.

It was the weekend we sailed to an island near Seattle that froze my instincts. There was a small marina and a park with miles of hiking. My mom fell from the boat to the dock and broke her hip. I walked alongside the boat to find my mother sitting in the cockpit with this distorted, distant look on her face. I knew that something was severely wrong. She was in shock. That is the point that I snapped. This was nonsensical. Why add on this cruel, unnecessary suffering of a stupid accident?

I paced the dock in the dark with my baby snuggled up to my belly in a sling. The whole dock was in a whispered hush from the atmosphere of a medical emergency. We were waiting for the EMT boat to arrive and take her to a hospital in Seattle. Someone came up to me and asked if I wanted to sit and rest for a while on their boat and have some tea. They saw me pacing and carrying the weight of my child. I thanked them. I felt their kindness, but no, I had to keep moving. I was utterly churning inside. My guts were raging a storm of nonsensical, blazing, white hot delirium void of reason. There was no reason, context, or sense in this idiotic accident. It felt ludicrous. My beautiful, lovely mother, already in so much torment, was now adding the excruciating pain of a broken hip. That glass. We kept hitting that fucking glass.

She first had surgery to repair the hip, which didn't work, so she

later had a hip replacement. My mind went completely blank when all of this happened. That is the point I wanted to walk away. It's why I would later feel relieved to just drive away from this bizarre misery.

I turned deeply desperate. Something in me shut off. I couldn't care about life anymore. We were absolutely victims of this disgusting, cruel life. Surely, I was walking in a dark tomb of accidents. There was no hope of improvement, just degressions. No wonder I felt this incredible apathy. I was the northern pike that had succumbed helplessly to the pane of glass that was forever blocking it from anything good; blocked from the sustenance of joy that life can provide, giving strength to press forward.

The pane of glass was later removed. My mother was dead and released from her torments in this life. Yet, I remained apathetic in my learned helplessness. The minnows of possibility and enjoyment swam around me. Their relevance was completely lost on me. I was not falling for that anymore. No longer slamming my face into that glass of surviving for nothing, that reckless battering of myself.

Who decided this life thing was a good idea anyway? Some twisted God creator? I didn't want to play this game anymore. I want out of this trick. It was not funny. I was not amused. I didn't want to

have to keep pretending I felt alive or have any desire for anything. I felt nothing, a deep void of nothing. I had no brain cells or energy to act in this world anymore. I longed for it to be over.

That's why this story of the northern pike study is encouraging to me, because I don't have to feel like such an idiot for thinking I am a helpless victim of this life and apathetic to possibility, to instinct, passion, or joy. I have been trained through my relentless life experiences that there is no point in trying or expecting good. Even when I had this beautiful family, friends, and life shining right before me. I had nearly given up. How would I reprogram myself to see, to realize there were beautiful things to partake of that wanted to fill me up to beaming and brimming? How would I create new pathways of understanding?

Devastation

MY HUMAN BEING could not process the magnitude of what I had witnessed and partaken of. My brain began shutting down in the torment. It was a sheer act of will for me to keep going. Love for my kids and the respite of alcohol continued me in a semblance of moving forward. And truly some small seed of hope must have been down in the deep of me. I had watched my mom persevere stubbornly and willfully. She kept her spirit vibrant. Surely, I could do the same. My pain was not physical.

It took me years just to let down from all the constant trauma. To let down enough even to begin the healing process. I had been trained into a very base, reptilian state. What was it like to live there, stay there, losing the nourishment and flavor of the spirit into the

soul that creates passion and joy? My soul is an emotional or intellectual energy or intensity. My spirit, which is conveyed rapidly and secretly, is the nonphysical part of me which is the seat of my emotions and character.

I missed my emotional and intellectual energy and the part of me that was the core of my emotions and character. I felt base, like nothing. I was missing my essence. What was left? My ability just to exist? I would often find myself sitting on the couch staring at the opposite wall. I had absolutely no idea how to keep going or what to do next. When it was time to make dinner, I would feel paralyzed. I didn't know how to figure out how to make a meal. I was overwhelmed to even understand where to begin. The myriad of emotions that humans get to experience was lost to me. I was numb. If I ever let myself feel, it was only this bottomless and penetrating ache. My energy was muted in numbness and despondency.

It takes a tremendous amount of will power to continue to live under those conditions. The core of my energy had malfunctioned. I needed to start over with my *why* for life. My *why* began with those first little seeds I deemed worthy of my tiny energy to plant. What miniscule energy I had to exist had to be rationed out to the thing with the biggest payoff. I couldn't be throwing around the

precarious wisps of energy on any old thing. I needed the biggest return on my investments.

Sometimes it was as simple as sweeping the floor, wiping the counter, heating up quesadillas, or playing Crazy Eights with the kids. It would take all my will power to get myself to do it, but I knew the feeling of accomplishment I would have as well as the fresh comforting feeling of a clean surface, little faces fed, or the connection with my children to warm the coldness in my heart. There would be a sense of peace, of settling. I would feel that millimeter of empowerment. I was at the very essence of persevering. What we must sometimes do because it is the only choice given us, yet it does something to build on, no matter how small, it is powerful.

Many, many things here on Earth are about persevering. I had persevered through sickness and death most of my life. It was time for the chance to persevere for life instead. How does one do such a thing? Especially when left with a victim mentality that I had completely and utterly subscribed to. It's a futile mentality telling me bad things will always happen, and I am completely subject to whatever comes my way. I have no choice or power to make anything different or to problem solve. It's an apathy for life. I had become invisible to myself. Forgetting that I could take up space or have choices.

It took me a long time to realize I could call out how awful the situation for my mother was. I thought I just had to be quiet and take it like a good uncomplaining girl. I didn't so much need to complain as I needed to lament. I needed a mirroring representation of how truly terrible the circumstances were. I didn't need to be quiet. I believe that is why I had haunting dreams for so long. My subconscious was holding all of that unrecognized emotion and imagery. It was asking, "What the fat am I supposed to do with all of this!" I would say, "Why don't you just hold onto it? You can hold all that, right?" My subconscious responded, "Are you kidding me! We are gonna lose it down here! You gotta get some of this shit outta here! You're going to lose your mind." And I did.

Apathetic

I HAD COME to feel like a helpless victim of my life. All recourses seemed dead to me. I was limp and washed by whatever came my way. The worst of it came when my mind started to give out on me. It too felt powerless. It feels weird to say with all I have been through, but losing my mental faculties has truly been the worst experience of my life. When your brain abandons you, you become the victim of your own self. And you are truly stuck inside of yourself. I was resigned to having absolutely no choice in life. It combined with not having the nerves to handle anything. My adrenaline was shot. I would find myself huddled in the corner leaning against a wall, eyes darting and frantic, breath shallow, and my hand bouncing repeatedly off my head. I could only stutter. I couldn't even communicate.

Whoever found me had to make soothing sounds to see if I would calm down. I had utterly abandoned myself.

How did I find my way out of that place? I decided not to give up. I was very supported by family and friends. I started drawing faces. I began to recognize and give credence to the being inside of myself. The one who gets to take up space, make choices, be relevant, and cause a ripple in the world. I began to recognize my ability to be big and spacious. Then all of the world seemed less like a threat and more like an opportunity, an adventure even. Little by little, the light of possibility came in.

I have the authority to steward my life. When you can show up as you, it's magical. I get to be messy, radiant, curious, and playful by trying new things. I can grow, create, be adventurous, and say what it is that I want. I began to embrace a desire to be the whole creature of the universe that I was made to be. Wild and radiant. Giddy and intense. Passionately patient. Boldly touching and rippling the atmosphere of the infinite universe. Timelessly creating, exploring, and putting my hands into life up to my armpits, my kneecaps, my toes and my hair.

Longings

MY LONGINGS BEGAN when my soul felt so weary from stuffing and holding all the fragmented pieces of my wounded parts in shadow world, the dark underbelly side of me. It got to be such a burden to carry all I was holding in there. I didn't want to carry it anymore. I wanted something entirely different than the drudgery of just making it through every day joyless, and numb except for the pervading ache I was constantly shoving away, hoping to wash away with alcohol.

What melted me down to let go? Was it weariness? Was it finally the longing for something different? Perhaps the acceptance of my humility as a strength and path towards my power as a human creature, instead of trying to control things. Am I willing to let go

of the idea that I am in control? Am I able to embrace the true freedom I have which looks different than what my rational mind imagines it to be? It's a sort of letting go in order to tap into a freedom in Source, where my soul is sacred and a divine part of the universe. Where I know the sacredness of the Earth, creation, and my heart. Where I can revere all those things with awe and mysterious wonder.

I finally gave myself the dignity of recognizing I am worth comforting. I am worth being whole, healed, and nurtured. I get to continue to be redeemed in these beautiful, fluid ways that touch my heart with delight. I get to accept these soft touches. Letting my guards down and feeling the healing kisses of tenderness towards myself. I have a gentle, soft side that is for compassion. It can fuel my powerful side. Then, out of my power comes a vulnerability and gratitude. There is power in my humility.

As I reflected back to the decade before my mother died, I had this vision of a little mouse. I see this vivid moment when I am at the hospital. The floors are dull looking but polished. Metal shines from seemingly misplaced equipment. A plain, tan nightstand is next to the bed. A soft, dated chair sits in the corner. Underneath the nightstand is a little mouse hiding. My mom is laying on the bed. My dad is off somewhere. I find my inner self in a realm of feeling starkly

calm, spent, unknowing, and tired. It's a sad and lonely place. Where it is too much. Where it is always too much.

In this vision, I come to the realization that it is all over. My mom's sickness and life are over. I can rest now. It is over. I can let the horrified parts of me rest. I get to do whatever I want, whatever I need. I get to rest.

That vulnerable part of me had hidden away, like a scared little mouse. It was brave enough in this moment to come out. I was feeling soft and compassionate with myself. It was wondering if there is rest and safety now. I had been horrified and afraid, really scared.

I thanked it for coming out and being seen. "I didn't even know you were back there," I say with gentle astonishment. "Thank you for finding a safe place to hide when it was too much, because it was too much." The mouse responds, "I saw you pacing these hospital halls so many times. I saw the haunted look in your eyes. I saw the gripping desperation and knew that you longed to be this powerful strength for the mother you loved so dearly. I also wanted you to be able to continue with life fully later, so I took your innocence and softness, even a bit of your compassion, and hid under this chair with them. I saw that you had to be tough. If it really is safe now, I would like to give them back to you."

With gentle, comforting tears, I replied, "I long to have you back with me now. I had felt empty but didn't know exactly what I was missing. I am looking forward to honoring and respecting you. I felt hard and harsh and lonely without you. I think we can do wonderful things together. I can feel you giving my softness, compassion, and innocence back. I was wondering why life still felt so hard, sharp, and edgy. I miss those parts. Life seems so much more cruel without them. I am glad you are still here, and I can invite you back into my life. Thank you for keeping those sacred parts of me safe. Keep talking to me."

> *The emotional wisdom of the heart is simple. When we accept our human feelings, a remarkable transformation occurs. Tenderness and wisdom arise naturally and spontaneously.*
>
> - Jack Kornfield

Therapy

WE CAN GO through many extreme situations and keep all our wits and functioning about us. Amazing, how capable we are. So versatile and adaptable. Molding, bending, and flowing to the river of energy life carries in us. Sometimes, I fall out of that energy river and find myself on VERY dry land. It feels a bit desolate. I thought I was plugging along, and then I am high and dry.

I experienced not just anxiety, depression, and grief, but there was also this strange chasm in my brain that had slipped away from the watchguards of presence and reality. You know when you do a meditation, it is all about being present and in the moment. There was no 'here' for me. I had drifted deep back in the recesses of something, somewhere else. Those gates of protection perhaps fatigued

from never going off duty, collapsed from exhaustion. I was left unprotected and desperate. Vulnerable and wasted. There was nothing left of me. I was a victim in my own land.

I found myself sitting on the couch staring at the ceiling. Had I missed something? Forgotten something? Left too many parts of me by the wayside?

That is what trauma and crisis does. It becomes center stage. You are brutally pushed outside the center of the ring. Something else is gruesomely more important. I became so small. I needed to not need anything because the crisis was too big, too epic for tiny me to take anything. My mother, the one I loved most in the world, was groaning in agony, stuck with needles and breathing aids. What could be more important than helping her stay alive?

I decided to try to pursue life and forward motion, something different than the endless cycle of death that was always running through my head. I found a therapist that knew how to delve into those deep places in myself calling out for recognition and compassion.

I sat on the office couch tense, paralyzed, and defeated. My despondency about life had separated me from participating. I dragged myself out of bed every morning as a shriveled human being. I barely knew how to take each step forward through the day. I did, however,

remember to breathe. The innocence in the faces of my three boys reminded me something in this life was worthwhile. Something was precious, but I couldn't feel the worthiness. I couldn't feel anything but the deep, bottomless ache. I just went on faith that there was something important and sacred about this life. I would get whispers of the evidence of it sometimes.

My therapist sat daintily on her stuffed chair, notepad perched on her lap, pen laying soft and ready. A poster of a rainbow-colored girl kept looking at me from across the room. She had tears dripping down her face. She looked like she had the possibility of answers.

"So, what's going on with you right now?" my therapist asked generously. My mind simultaneously raced and went blank. I had to wade past the feeling that I had to perform. I was sitting there because I couldn't perform anymore. I could barely do anything anymore. I barely wanted to be alive. I didn't want the respite of death so much as I wanted a respite from life. I didn't want death to feel like the only road of possibility. I wanted to find a way to turn and veer in other directions. I needed more options than what I had figured out on my own.

On my own. Isolated into thinking that everything was always on me and me alone. Somehow the weight of the world had fallen on my shoulders, and I was feeling crushed under it. I knew I

couldn't carry this weight much longer. I didn't want to. There was a hint of an idea that I wanted to enjoy something, anything. I was sitting here because I thought even if, by some miracle, it was possible to feel something different again, perhaps a drip of joy, I could have the energy to keep going.

Depression had dropped me into a pit and left me there. It was so dark and cold. I had no desire for anything except for the desire to desire. My therapist gave me some exercises to take my hot thoughts to court in order to decipher the possibilities of different ways of looking at a situation. I hadn't even known that I had that option. I only knew apathy. I was ready for something different. Eager with desperation to not have to live under this weight of helplessness anymore.

Becoming Risky and Going to Court

I LET MYSELF become risky, messy, ugly even, curious and playful. The hardest part was realizing I had no idea I was steeped in this apathetic state. The stark realization came as I was ready and open to see with my intense longing for a different feeling about life. Come out of the dark shadows, Andrea.

My therapist revealed my deeply entrenched apathy for life. My experience of relentless medical trauma served very well to reiterate my beliefs about life being so futile. I went home with a revelation of the victim mentality I had sunk so very far into.

What is a victim mentality? People who have a victim mentality believe life happens to them rather than for them. As a result, they are quick to feel victimized when something doesn't go as

planned. At its core, a victim mentality is a form of avoidance.

It is only when I was ready to shift my perspective and see the events of my life as fully in my control that I could step into my power. To stop avoiding life so I could begin reckoning.

It wasn't so much that I wanted to have a pity party. It was more that I didn't validate the trauma I had experienced or was even able to talk about it. I didn't really know how to consider it except to figure out that life is out to get you. It piles one horrible thing upon another and never gives you a break. I came to assume that from life. It was hard to figure out how God fit into this really harsh and cruel paradigm.

That night, after my therapist revealed to me this apathetic mentality I had so deeply subscribed to, I had the worst sleep of my life. I was tormented by the realization I couldn't even trust my own self. I had taken on this horrible view of life, and it was making my existence miserable. I felt like I was the demon that had sabotaged my own self all these years. Yet again, I was the victim but of my own making. The ultimate victim. I was horrified and anxious, feeling betrayed and devastated by myself.

It was this initial awakening that helped me to realize that I could make choices and affect things. I was figuring out how to know I have power and authority in my own life. It started by being

deeply in tune to my soul's language and longings. To sit quietly and hear. To claim those things deeper inside of me and decide what I wanted to take from those things. I got to decide how I encounter myself and my experiences.

I got to decide I have the power to make choices. I got to hold before me options instead of disengaging. The thing that freaked me out the most was not realizing what I had been doing. Not realizing the rules I had made to disregard myself. And not knowing how empowered I actually could be in order to encounter whatever life may throw at me.

My therapist gave me tools, exercises to learn how to decipher my perceptions and transform them to something new. Exercises with the intention to figure out how I would actually like to view myself and the world around me. I could take a triggered emotion and bring it to court, deciding how I wanted to hold the lens to that experience, getting to shift my view the way I want to. I get to choose how to tell my story.

Mindset: I'm responsible for making everything okay for everyone else.

Rule: I have to disregard myself.

Prior Experience(s): My mom's suffering trumps everything else or me.

<u>Vow</u>: I don't need to require anything.

<u>Automatic Process</u>: Not let myself acknowledge how I feel.

<u>Which Makes Me Feel</u>: Stifled, helpless, trapped, no choices, powerless, work really hard to protect myself.

<u>Which Leads to</u>: Depression, despondency, futility.

<u>Which Formed</u>: Self-reliance and isolation.

I tried taking my emotions to court. While driving home, I passed a car crash. I was hyperventilating with panic as I looked at the people having to contend with the crisis. I was triggered by their trauma.

<u>Situation</u>: Car crash in the road.

<u>Mood</u>: Disturbed 80%. Distraught 85%. Anxious 70%. Horrified 65%. Sad 40%.

<u>Hot Thought</u>: The worst is happening. It's only going to get worse from here. We are all doomed to suffer over and over again.

<u>What makes the hot thought feel true?</u>: I watched my mom have one crisis after another. It was always terrible, and it always led to another terrible thing. Therefore, when a crisis happens it will always lead to more crises.

<u>What is NOT true about the hot thought?</u>: This is just one accident happening. The people will heal and recover, or not heal and/or die,

but then it will be over, and they will move on with life. They will not keep having one accident after another.

Balanced Thought: While I did watch my mother have one crisis after another, it is also true that this is a single accident that is happening and will not continue happening. It will be over, and the people will move on. They are not stuck in the situation of this accident. Mood: Disturbed 15%. Distraught 10%. Anxious 5%. Horrified 2%. Sad 30%.

It was the beginning practices of this exercise that I started to grow and build a sense of empowerment. My current situations did not have to be dictated by my past experiences. It was so liberating to recognize how I was viewing my current life based on my past, that had nothing to do with the present moment. I didn't have to relive the past through my present. There was a way to understand my paradigm, legitimately framed from my experiences, while also getting to live a fresh perspective.

I was learning how to give this new space of recognition for myself. I had forgotten to consider myself and have any sort of sense of what I needed to do to care for me. To acknowledge my needs and get to say, "Yes, this is so hard Andrea. This is not right. It hurts so bad to have experienced this. The emotions and lament you feel for your hard situations are exactly true and you get to express them in

all their raw energy. You also get to experience softness and holding."

I had shut off the ability to know that I can mourn. Until one day, I collapsed on the floor, out of the blue, gripped in body-bending sobs, for no other reason than that I carried a magnificent amount of unlamented sorrow. My physical body gave out from the effort of carrying it. My mind began to misfire from the fatigue of guarding and holding vigilant this empire of untapped sorrow. My body and mind collapsing were the final, desperate signals for help. There was no more "just functioning". I tapped out. Humbly, I give up trying to hold it together anymore and to be what I thought I was supposed to be. Because I am absolutely worth it. How painful and hard is it to say and recognize that? I get to exactly be me.

After Forty

AFTER MY 40TH birthday, my knee gave out from an old ski injury. I was on crutches and proceeded to schedule a knee surgery replacement. I joked that I had to get an honorary 70+ year old ID card in order to have this procedure. I was once again living beyond my years, too old for my age. Everything felt out of order and out of place.

I was at a dinner with two couples my parents' age. They were talking about the stage of life they were in of taking care of their parents in old age and all that comes with dealing with end-of-life care. I could barely listen. I was so confused. Stunned emotion washed over me. These people were 30 years older than me, and they were just now doing parent caretaking. Something was amiss.

I had already taken care of my parent and my mother was now dead and gone.

No wonder I often feel like an alien amongst my peer group. I had been like an older person most of my life, carrying burdens beyond my years. While kids my age had been going to college, partying, dorking around, discovering themselves, and experimenting, I was giving home IV medication, doing full time care after heart surgery, helping to bathe, feed and rehabilitate, keeping watch, tending to precarious needs, and rushing to the emergency room. It was a strange backwards world. The burden pressed heavy on me.

Moving to Texas gave me the chance to begin to recover. I surrounded myself with a beautiful community full of rich history and like-minded, intimate-hearted friends and their families. I began to learn how to open up, let others in, and let my guard down.

From what I have looked into, it is hard to find information about experiencing Post Traumatic Stress Disorder (PTSD) outside of the typical war or abuse situation. I had not been in a literal war, and I had not been abused. I was starving for validation of what I was feeling from the stress of my experiences. Chronic illness is a brutal companion. It starves you of dignity and puts you in this warped place of survival. It leaves you ragged and full of deeply painful triggers.

It helps to be able to validate PTSD in those who have partaken of extensive human suffering. My therapist even asked me if I would diminish the victim of a concentration camp experience. Of course not! Duh. "Well, it's the same thing. What you went through," she said. I saw the haunting skeleton of my mother's body in that moment, moaning in her last week of life. The perpetrator in our situation was life, so I didn't have a way to justify its hardness. No one to blame. There was no reasoning behind the results of our circumstance. The sense of urgency to keep a loved one alive. The sacrifice and vigilance it took to stay in the war for life.

It took years of slowly letting down, a resting process, until the day I discovered art therapy. I found a language to call out my many lost selves from the shadows and to slowly draw out the long shadow. I was reclaiming so many wounded parts of myself through imagery journaling and validating all the things below my consciousness. The vital parts of me.

I had lost my innocence and I wanted it back. Knee surgery felt like rock bottom, the end of anything good able to happen in life. "Fine. I give. I've got nothing," I'd think. My last piece of dignity taken away. Something snapped in me, a letting go. I think I gave up on feeling like I had to try so hard. I gave up on thinking I could control anything. It also felt like a complete liberation from

what I thought I was supposed to be.

I'm a fighter. I worked hard after knee surgery, determined through physical therapy to regain my strength. I also gained an unbelievable appreciation for the courage it takes to go through physical therapy. These are folks who have nearly lost all their ability to do basic functions. I have incredible patience and compassion for losing the ability to function. It can so easily bite at your heart and hope. I believe it takes tremendous bravery, willfulness, and defiance to take those tiny, excruciating steps to regain basic functions. I had to push past the deep searing pain just to bend my knee and straighten it for a few seconds. I admire the determination it takes to work so hard, through so much pain for such tiny results, much like my mother did most of her life.

I watched other patients strain to barely move their legs or exert everything just to take one step. I wanted to cry with admiration at their bravery. I could tell who had accepted their lot and persevered with humility and gratitude, and who was bitter, angry, and resistant.

I have had many great moments to pause and be grateful that I can walk again. To not take for granted the things we expect to be at our disposal. I have been very much spurred on since my recovery to make a point to do the things I enjoy, like hiking, biking, and camping.

I went through weeks of searingly sleepless nights. No one told me how painful it would actually be to have my knee replaced. There seems to be a conspiracy to hide that from patients, possibly to not scare them. Spoiler alert. Even my grandma who has had knee surgery multiple times failed to mention this. After my surgery she told me, "Yes, I didn't want to tell you how painful it is." At least I was getting affirmation after the fact.

Fortunately, I had the Gilmore Girls to keep me company on those sleepless and pain-filled nights. Gilmore Girls had been a favorite show of my mother's in the last years of her life. It too, distracted her from the torment of her physical pain. I would hear her talk about it but had never seen it myself. I had only recently gotten up enough nerve to watch it for the first time because it had been too hard for me to engage with since my mother had died. Now, it has become the sweetest comfort to watch. I can feel her right there with me every time. I can taste her in the air. I get to see the special connection that mother and daughter hold and know with fondness the one I have had too. Best friends as a part of the ins and outs of life together. Cheering each other on and feeling each other's joys and longings.

It's the relationship where we advocated for one another no matter what. The one where my mother is in the ICU puffed up like a

balloon from IVs, barely able to talk and all she can say is, "But it's your birthday tomorrow Andrea. What about your birthday?"

When I am at home with a baby and a toddler as an exhausted new mother, and my mother came over and insists on washing my dishes to help me out, even though her legs feel like bloody stumps of burning pain from nerve damage. I helplessly let her wash the dishes. Feeling so loved and sacrificed for while knowing that she will be lying in bed the rest of the day and night in even more excruciating pain than she normally had.

That's when you know your mother really, truly and graciously loves you. It is such a tremendous gift. It is a kind of a tormenting one also. I don't think I fully realized the power of the energy she gave in that sacrifice. I had a chronically ill mother and she still served and loved me. It was only a drop of what she wished she could do, yet it was potent with power.

Discovering Art Therapy

ONE DAY I happened to pass by a studio called The Art Station. I was instantly intrigued. As I explored and researched this concept, I came across a lovely course by the gracious Shelley Klammer. I was utterly fascinated by the concept of a language that I could use to express myself in imagery and color. My deeper longings didn't have to make sense in words or concepts. Imagery overrode the need for rational brain work. It let my emotions simply be. I got to just be in mysterious essence, to speak from my under world. I heard and brought my soul depths up to the surface, my sense and intuition ignited. I found a courage and boldness to acknowledge and awaken the hidden and unlamented.

It was total freedom to just close my eyes and be. There was no

more pressure or exterior stimulation just the space for the deepest parts of me to rise and be held with curiosity. To be seen from the internal energy of my passions and not a contrived energy of what I thought I was supposed to do or be. Those first strokes of oily color, smooth and thick, boldly seen, opened this valve of relief. I could let the fatigued guards of fear and protection step down in those moments. I could let down like I never had before in my life. I could cherish a moment that was not about anything other than just being present and fully expressive.

I did my first art therapy on my own from a written lesson. The instructions sounded so bizarre.

Step one: Take five minutes to quiet your mind and breathe.

Step two: Pick a color you are attracted to, and make loose marks on your page.

Step three: Keep picking colors and making marks in an unplanned way.

Step Four: As you spend time looking at your drawing, see what spontaneous words or phrases arise.

I kept thinking, "Ok, I guess I'll try that, but it sounds really weird." I let myself have faith in the process and I was blown away by what I discovered. Little by little my paralyzed insides were brought

out and resuscitated. It was small at first. A lot of breaking away from dead tissue. The tremendous gates of fear loosening and cracking.

They were little tastes, morsels of what it felt like to be alive, instead of numb and depleted of energy and motivation. Enlivening came through color, line, and shape. It came through images and symbols. Symbols can have a very powerful significance and effect on our psyche as a deeper power to transform. I was awakened to representing my emotions, my soul language, and my intuition through a tangible medium. The abstract becoming more coherent, more true and pure, than linear words and rational thought.

I was unfolding a story that had already been written. I was preparing to detangle story from soul. I saw the depths behind the character of me. I saw what had formed and shaped my paradigm. I saw things wild, exciting and free, beautiful, and willful. It was this incredible journey that I longed to keep coming back to and be surprised by what I would find, like treasure hunting.

I would indeed find many pockets of deep ache along the way. Dipping into those places let out a volcanic lava flow of grief. It hurt unbearably. I knew in those moments why I had been guarding and stuffing away those emotions. It was open heart surgery in the act of accessing and pulling out the purity of truth in those memories. The part I recognized more powerfully than the pain

though, was the incredible relief I felt afterwards. A veil would fall away and I had become more of my real self, unblocked. One less thing I had to guard against, and I could use that guarding energy for enlivening the longings and passions inside myself instead.

I witnessed something important inside of myself, and I put the authority to decide in my own hands and my heart. Suddenly, I was the storyteller in my own story. I was not the victim in a strange land. I became the orchestrater instead of being an apathetic bystander of my life. I described the view. I got to be the narrator. I loved the energy, power, and authority I felt in this.

I began to let myself feel angry about the things that had happened to me, to those I loved, and for all I had witnessed. I called it, "This is not ok. That was really messed up." And I sat right next to myself as the sorrows came and melted me. "I'm so sorry that happened to you. That was hard. You should feel exactly what you are feeling." I said this with gentle compassion to myself. I sat in that sacred heart space and let myself feel to the bottom of each scene that wanted to come up.

I began to enjoy being with people again. I was learning how to problem solve basic things like making dinner. Even though my brain felt hijacked, I was learning how to use it again to learn new things and share those new things with friends. I spent two hours

every day for a year delving into these lessons of art therapy.

> *Where there is a creative mind — reason — so it seems to me —*
>
> *relaxes its watch upon the gates, and the ideas rush in pell-mell.*

– Sigmund Freud

Finding My Why

I WANTED TO find a way to pursue life that involved something substantial, that gave me a deep-down feeling of *yes* for life. I wanted to lose the desire to light the matches or use the knife. I slowly recognized that I deserved to fully tell my story for myself.

I learned a little expressive arts activity that very simply and softly let me loosely draw a face by adding drippings of watercolor and thick cakey colors of oil pastel crayons. I began to draw lots of faces because they gave me such a satisfaction of seeing, hearing, and recognizing these places deep within me. I ripped patterns and color, words and symbols out of magazines and pasted them on my faces. These expressions took away having to explain with words or justify what I might be feeling or why. It just gave me the opportunity to

be. That was what powerfully mattered and gave me the invitation to heal.

I took a black watercolor pencil and drew little scribbly circles for the eyes, a simple line for the nose and mouth, a chin and jaw, and the shape of hair. It was so gentle and basic as I softened the lines with a wet paintbrush. I chose one color that jumped out to me from my watercolor palette and circled color around the eyes and under the chin. It dripped and flowed around the contours of the face. I added another color on top in places. Some of the colors mixed and dripped further. It felt like emotion alive, active, expressing on its own.

I ripped out patterns of shape and color from a magazine and pasted around and over the face. I defined parts of the eyes and rounded out the lips. I added color to the hair in oily pastel that left thick definition and dense, bold color. I found one phrase to tear out that energetically jumped out at me, DARE EXPOSURE, and pasted it on the page to claim my picture.

Sometimes my faces would look lost or forlorn, sad, pleasant, delighted, innocent, angry, despondent, or wild. I was letting the thousand sides of my inner person out in recognition. I became almost obsessed with doing these. Sometimes several times a day. I found a space of recognition. Where the sorrows and the joys

and the indescribable had a chance to be known out in the air, out from the shadows and sit right in front of me.

I was relieved to be exposed. I began to experience a lightness in my days. When the kids would get home from school, I found myself engaging with them more earnestly and with ease, instead of a strained tolerance. Tasks around the house that had seemed insurmountable began to come into focus.

Now I am surrounded by faces, in journals, on the wall, scattered throughout the house, and in the hands of a few friends. I am working on a thousand recognitions of myself and my experiences. The tangibility of them on paper gave credence to their validity.

Many of my portraits of late have been bold, resolute with a sweet and graceful softness about them. It felt like a brave and wonderful encounter of myself; like I am standing up proudly for my entirety.

Recognizing Faces

IN MY EXPRESSIVE arts lessons, this activity of drawing faces had become an incredibly gripping and reassuring practice for me. These portraits brought out my sorrow that was tucked in so deeply from my childhood.

I had drawn a spontaneous face and found myself looking at a haunting face of a child. One tear was overflowing an eye, like a dam about to burst. I was totally creeped out by the expression on this face, lips parted in a look of helplessness and haunting. It took me months to be able to look at it with interest rather than revulsion. My curiosity grew into fascination and a strange comfort in this gripping portrait. It finally dawned on me this was my childhood self. This part of me never got to cry or express sorrow for what I

felt. It took a lot of courage for me to be able to recognize that. The picture became so precious and meaningful to me because it let this unlamented part have the space it deserved in a sacred recognition. It brought out the sadness that had been tucked so deeply back. It felt like a sweet release that gave me permission to be where I had been and also to move forward.

I have found many of these witnesses to suffering in my portraits. They are looking deeply inside the haunting. It has been a relief to encounter and reckon with them. I have had many faces with red tears and streaks. All of these are done spontaneously without any premeditation. I show up to a blank page without thinking and see what wants to come out.

The red tears started to alarm me. It was a gruesome sorrow I was holding inside of me. The goriness seemed to overtake everything else. The love I felt for my mother and received from her seemed to be trumped by the horrors of witnessing her decay.

I also had many faces show up full of resolute vibrancy. They reflected something gorgeous inside of me that deserved recognition. These portraits show that I have seen and known treasures that break the barriers of the universe and time. They press eternal. They are sometimes fierce, peaceful, soft, gentle, quiet, powerful, or oozing with sorrow. They are a wonderful and soothing recognition.

They give a comforting affirmation as a mirroring of my soul.

This is a therapy of non-rational wisdom in imagery. This powerful recognition of soul speak that heals and empowers. That gives choice. I felt helpless for so long in my deep depression, my grieving, the PTSD of all I had witnessed, the cracking of my brain, and the paranoia of existing on such a threatening Earth. Not knowing what was real and huddling in the corner and not knowing if anything was safe. Is it ok to breathe? Nothing was safe. Life was not safe. How do I breathe?

I had a long dark time of assuming I would lose any or all of my precious family at any moment. John would be late coming home from hanging out with friends and with a calm acceptance, I understood he was most likely dead. A love I would also no longer have. It was with a sort of despondent resolution that this is how life treats you. It felt like a veritable Hunger Games. "Oh, I get it God. You created this arena of Earth and stuck us all in it, letting all these hideous things befall us, disregarding human dignity."

I had lost all vision for beauty in life. Along with that lost vision went my joy. It took so much courage and fight to get up each morning to face another day. I had honed it down to recognizing that I only had to get through each minute. That felt manageable. There was hope in that. The possibility of something surmountable.

I vaguely saw the lunacy in it, but it was all I had to navigate each day. Then I discovered those faces as a recognition, a sign of life inside myself. It was like finding life on a barren planet. Ecstatic revelations. A new territory to be discovered, developed, spacious, open, wild and free.

Those first faces I drew gave a voice to those feelings inside. They gave a point of reference for my longings. They gave me a way to ask something different of life and to also see the beauty and power in myself. I saw something fierce and determined come out that wanted to live wildly and not miss the privilege of life.

A Portrait Talking

I'D LIKE TO give an example of my reflection of a spontaneous portrait that I just drew because I was having a hard time writing today, and I thought if I drew a face, she might be able to help me. I have a blank page and a pencil to start. Sometimes I close my eyes while I draw or use my non dominant hand in order to lose my inhibitions. I want an absolutely candid and authentic expression. I want to hear what the silence is screaming.

I often spend time spontaneously writing what I see in the portrait. This is the reflection as a stream of consciousness I procured after pondering this face I just drew:

She looks tired, feverish, and distracted. There is a tick in the back of my throat. My rational brain no longer has sense in it. She gazes

mysteriously with longing. She has loosened away from something. The blood stains have not yet washed away, they hold fast. There is a lightness in her face. She has dived down and greyed her mind with wisdom. She has found softness in the holding of precarious things. I want the soft body of my mind.

I am absolutely anxious with emotion. I see the rain coming down out of this window and feel the washing relax my vigilance. What am I so vigilant about? I see her face staring at me, reminding me of serenity. She is astute. She knows powerful mysteries. She has glanced and gazed intimately. She sat on the cliff with eagles. An ocean gazing perch. Mesmerized by its boldness, its daring to be so exposed and visible.

I want to be daring and visible. I want to take these hands stained with blood and draw blooms of flowers with them. She dares me; she invites me. She says I can come anywhere with her. She says I can do things with ease and peacefulness. I don't have to try so hard. I don't have to be on guard. I no longer need to use energy on my watch gates.

There is a whiff of tragedy lurking. The threat to life and love always there. She is telling me fiercely to be vibrant. She is telling me there are bouquets of color inside of me. The possibility of extravagance in experiencing and experimenting this human life.

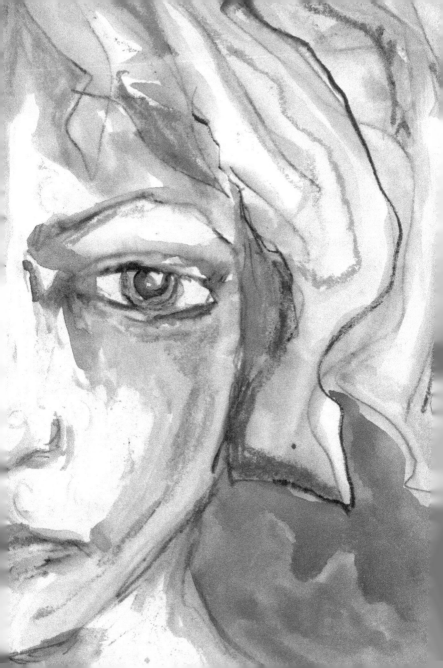

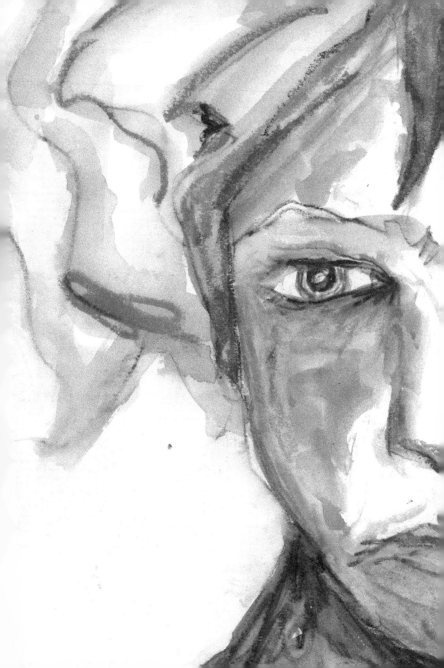

Authority

I AM THE story-teller, the decision maker, and the authority over my domain on this Earth. I can turn the lens and the spotlight wherever I wish. I am the orchestrater. How many points of intention will I hit on? How will I keep going in a spacious reforming? I let them (my portraits) look at me and help me tell a new version of the story. I let them bring brilliance. I let them recognize an ache, and I let them accentuate a beauty. I let it be something solid, tangible, and mysterious but not elusive. It is something I can capture from deep within me. I want to cry with the sheer lifting of the weight of darkness. I can stand with light and recognition of refreshing air in my lungs, not gasping and heavy for breath.

In these moments of creativity, I get to slow down and enjoy

eternity. I recognize and affirm there is nothing pressing me. I am right on time and exactly where I am supposed to be for exactly how long it takes. This time I take to engage with myself in the subconscious finds me my superpower in my own unique human being.

I want these faces to keep looking at me and tell me these things. Letting their truth seep through my pores into my veins and through my heart. I get to naturally have a perception of there being so much possibility in everything.

Yet, I can still find myself so antsy, resistant, and churning inside. Tendons feeling stretched and pulled. The rain of recognition will wash away the strain from inside of me. I close my eyes and let it. Where am I imagining this pressure is coming from? There must be some imaginary threat dictating me. In what ways do I think I control my exterior world? I'm not performing. It's about finding a confidence in my essence. Determined to live out of my truth source. I am an image of something superior and I am a single unique reflection of universe. I am an image bearer.

Permission

I Give Myself:

Permission to have a hard time from my past experiences.

Permission to be fatigued and drained.

Permission to give myself compassion.

Permission to be sad my mom is gone.

Permission to be horrified at what happened to her.

Permission for it to be ok for me to shut down mentally.

Permission to be affected by crisis.

Permission to detach from parts of myself that were too hard.

Permission to reattach when I am ready.

Permission to give myself space and time to integrate new
discoveries of me.

Permission to be exactly where I am.

Permission to be patient with myself.

Permission to give myself space to breathe and let down and relax and take things in and feel myself out.

Permission to not be perfect and have it all figured out.

Permission to not be critical of myself.

Permission to be gracious with myself.

Permission to have unconditional love.

Permission to leave space for myself to think, be and know. To feel, have ideas, and dialogue. To be creative and interested in things.

I find it interesting that I even have to make this list for myself. Why didn't I know all of this already? How did these completely essential things get lost? When did I not know them? Did I ever have them? Did they just get shuffled over? It seems it can be the hardest thing in the world to value oneself.

Perhaps that is the curse, that we have all forgotten how important and valuable we are. God created this impossibly extravagant world. She deemed us worthy of creating and presenting us to this immaculate world in authority and relationship. It is this privileged space we take up. We are deemed important enough to take up space. There is a voice of disparagement we combat in order to

take up our rightful place, in order to be streamlined in seamless connection with our Creator; the gentle voice of affirmation to our own unique value.

As King David puts it:

> *Look at the splendor of your skies, your creative genius glowing in the heavens. When I gaze at your moon and your stars, mounted like jewels in their settings, I know you are the fascinating artist who fashioned it all! But when I look up and see such wonder and workmanship above, I have to ask this question: Compared to all this cosmic glory, why would you bother with puny, mortal me or be infatuated with Adam's sons? Yet what honor you have given to men, created only a little lower than Elohim (Creator-God), crowned like kings and queens with glory and magnificence. You have delegated to them mastery over all you have made, making everything subservient to their authority, placing earth itself under the feet of your image-bearers. All the created order and every living thing of the earth, sky, sea – the wildest beasts and all the sea creatures – everything in submission to Adam's sons.* *TPT

Authority. We are an authority. We must be the threat to some sort of universal fight for the order of things. I am realizing, validating myself, and asking nurturing questions. What fills me up and inspires me to a more bursting energy? What compelling voice do

I hear from deep within me? What inspires confidence because of an authentic, candid drive? What gets me excited to keep moving forward even in the small things, like watching a tiny seed sprout and grow? This is recognition of the powerful place we hold on this earth. We are not mistakes or grossly damaged things. We are loved, desired, and essential.

I don't have to be disengaged. I can know intention. If I have a longing or desire, there is truth in it. I get to learn how to hear my intuition and tap into its wisdom. I have begun doing this by using spontaneous creativity. I like to think of it as arts in the raw. I get to reveal my inner language, validating my core, and giving voice to it. It helps me see the story and shift the perspective of that story to exactly what I want it to be. It produces healing, revelation, and authenticity. It gives me this wild, spontaneous space to be really free and curious while asking questions without having to know everything. I let my fear guards out for a smoke break while I safely delve into the shadowlands of myself. Some things I find there are painful, but oh what an unburdening by revealing them. I become lighter and more empowered with each finding.

Frankenstein Alive

S PONTANEOUS EXPRESSIONS WITHOUT technique, raw and candid. I am finding gentle and playful ways to engage with myself. It is a little out of my comfort zone and a lot of letting go. I am using whimsy to find that authentic self and those tender spots that call for healing.

I sit in my art studio lost and absorbed. I am inside of; color and shape, poetry and texture. The energy of something deep inside of me bursting out. I love discovering this thing I like to call arts in the raw. It's a place of deep candor where the door to the emotional wisdom of the heart gets to be revealed by using color and imagery as language. Even my awkward, unfamiliar steps forward are important. Letting my authenticity to myself validate my life experiences.

I am finding a path out of the cold rational of suffering I experienced into the affirming light of the intuition of my emotional existence. I am learning how to be present and intimate with myself. This was my awkward and uncomfortable beginning. It was like prying open a massive steel door that had been fine-tuned to fit its weight securely in place to cover the raw emotions I hadn't faced yet, and not knowing how to have a context for my pain and trauma.

I had my moments of breakdown, but mostly I was stone-faced and calm in the turmoil of my life. On the outside anyway. Inside, I was dying. Completely deformed with confusion about reality.

My life had turned into science fiction. It was grotesque with holding up a body gone into disfunction. Nothing worked correctly. We were holding up a body that was limping along with everything the medical field and science could do to keep it artificially going. It felt like Frankenstein's creation in its hideous impossibility. Yes, you are technically alive, feeling the fullness of your soul and spirit, but you are relentlessly tortured by the gruesomeness of your existence. Organs cut out, transferred and sewn into place. Organs taken from not only dead bodies, but the living body of my brother who still had a life to live and a family to raise and love.

I'm sure my brother's emotions are also in partial paralysis in regard to this. I am still in shock and mourning that he gave up his

kidney for our mother. I sat quietly through the whole miserable thing. I sat and watched this horrific act. It is such a noble act, but I think it is also a foul business. It eats my heart to remember. I can reconcile none of it. My mom is dead and gone now. Her life extended by an extra eight years from Adam's kidney. Now Adam has the rest of his life to contend with the health consequences. How many years have been shaved off of his life with the sacrifice? Who should ever be in the business of deciding to transfer years of our lives to each other??? Perhaps all I can do is curl up into a ball, hold myself, and lament for my brother. I am angry, but that is tucked back pretty far behind the sorrow.

I think I am torn by my love for both of these souls, these beautiful spirits. They are both precious to me. I don't want to have to decide how to dole out their lives.

My mom got to live another eight years. She got to meet all four of her grandchildren and impress her loving mark on them. This is what kills me because that time was so precious. Their spirits colliding beautifully in love on this Earth. Wouldn't I sacrifice anything for that? Yet those eight years were also hell. Our family mostly alone in this fight to keep her alive under cruel circumstance. About once a month she was in the ER with pneumonia or something equally traumatic.

Transplant patients go on immune suppressant medication so that their body won't reject the organ. As a result, they end up catching every bacteria and virus. That's something they don't make clear enough when you learn about your organ transplant. I took the pre-class as a caretaker of the patient. They don't tell you how devastating it can be to live with a severely compromised immune system. There should be more questioning of the consequences, and weighing what we are willing to do and sacrifice just to stay alive. We have way too much control and too many options in our truly limited understanding. This is the other side, the other face, of medical trauma. The one that is stark and gruesome. Will we do anything in the vein of science just because we can? Sometimes it feels perverse.

Those eight years between her transplant and her death were a nightmare. Time became a wadded ball of medical circumstances. I have done a lot of therapy to process it, yet I am still haunted seven years after her death. I at least stopped having the nightmares. There were always these hideous things going on with bodies in them. Bodies that were being blown up, emaciated bodies dispersed along the crevices of cliffs that almost look like just bones with skin hanging around them, and this decayed look in their eyes. I am trapped somewhere in the middle of the cliff or the center of the explosions, looking at all these eyes and body parts. My mind and emotions have

no way to make sense of the grotesque ways I have witnessed my mother being tortured by her body.

I did a portrait not long ago that ended up reflecting the time after mom's transplant. This poem is the original, raw reflection that came out. I haven't altered it because the candid emotion it captured feels sacred to me.

Transported indecently
Feather mask
Popping tigers
Drained blood
Hideous death
Traveled journey
Important task
Mishandled
Doom and dire
Trembled and hand
Shaken down
Fallen
Steady ran
To hopeless survival
Trained thick
To endure long
Haphazard
Draining system
Long past vibrant
Long past survival
Into the gut fuel
That rides you forward
Traversed and toppled
Ever hanging systems

Of decaying strength
Death prolonged
To mutant end
Tragedy torment
But the dream never ends
I try and try and try
But I have propped up a
Corpse, writhing
It's my fault for keeping
It alive so long
Tremulous
Agony's stench fills
My nostril and my brain
It's hidden in the crevices of
My flesh
The retching, the moaning
I close my ears but it
Echoes long
The body that sinks
Brain collapsed
But I love that soul and that
Spirit
Does compassion keep it alive or help her enter the door of
death?

This poem was my way to begin encountering how hard the trauma was. I wasn't traumatized by just one horrible thing happening. I could have handled that, healed, and moved on. It was the way that one horrible thing happened after another. It just compounded as the years went by and her new kidney began failing in the end. I

wonder at how long I would actually need to hold myself to lament all of it. Perhaps I will always carry a sadness with me because of what I have seen and known. That's where my fighter comes in and determines I will grab beauty and joy wherever and however I can get it. If I'm going to have to persevere in this life, I want it to be towards something glorious, not to just get by and survive. I am deeply exhausted from just surviving. I stubbornly want more.

My mom was always nauseated and always throwing up. We were endlessly praying she would be able to keep food down. Most of the time she would just end up in the hospital. Helplessly. Hopelessly. I think it would have been nice if someone had come to me. Anyone, even a stranger, to tell me that seeing my mom in that condition for so long was not ok. They could put their arm around me and tell me that this was a tragedy that I was living right then. Don't delude yourself. They would tell me, "I am so sorry you have to helplessly watch your mom go through this." I would have melted into a puddle. I would have felt the refreshing and absolute relief of recognition that this was a terrible situation, that it was more than I should have to bear. I wasn't made to hold this much sorrow and witness this much suffering.

I had been marching forward, resolute, and soldier-like. Feeling anything was never an option. I blocked all that away and fought

my way forward, pretending that we had a chance at survival. That this wasn't all going to end worse than it had started. My mother dead, my brain fried, completely incapacitated at having the ability to function normally and handle regular life.

I wish that anonymous person could have told me, "Why don't you take a little break from all of this? You realize you don't have to carry the weight of this all the time, standing vigilant these endless days. You can step away and have a renewal. You don't have to be on a shift every time she stays in the hospital. She and your family will make it without you. And it will leave room for someone else outside of your little circle to step in and carry some of it. You can't actually stand under this much pressure for this long. You are merely human after all. What would be the most recharging to you? What would fill your heart with delight right now?"

Then I would have gone hiking and let myself get lost and washed in the purity of nature.

Death Views

MY VIEWS ON death have changed after witnessing someone suffer for so long. I welcome it. Death is a conclusion. I am reassured in the certainty of death. When death comes, it will be right on time. It is something that we can absolutely depend on. In this hard fought, excitingly glorious, and tedious life we get to know that eventually, it will end. I don't have to concern myself with its timing. That's death's job. Life does not go on forever. We don't have to work so hard forever. There is a limit and a boundary to our time here. And it comes exactly when it is supposed to come. I don't have to worry about it or consider it or hold an energetic space for contemplating where and when it will show up. I can do my best in this life, make the most of it, treasure that I have it, be responsible, and

feel reassured that death is doing its job. I am in the business of life.

My mom was in the business of life. She fought to stay in this experience. Seeing how strong her will was to stay alive continues to inspire me to ponder the possibility of there being something really important about life. She fought through a lot of pain and agony to stay present and make sure that everyone around her knew how boundless her love was for them. How highly you were held in her regard and how much she would genuinely sacrifice for you. I was indeed instilled with this deep and powerful love. I think it holds me firmly to the ground when nothing else makes sense.

Arts in the Raw

IN ONE OF my art therapy lessons, the instructions read like an abstract and mysterious language. Close my eyes, see shapes and color, don't think, just feel a color that resonates. "Ok, that sounds weird, but ok, I'll try that." I opened my eyes and looked at my palate of oil pastels. Instantly a shade of orange jumped out at me from another dimension, racing its ghost body towards my eyes. I reached for it with my hand, not hesitantly but deliberately and with resolve. Without thinking, I brought the crayon to the blank page and watched what my hand would do. It started moving in its own motion, marking and flowing. I watched my hand intentionally grab a different color and continue to make marks. It was effortless. I felt a relief in the almost hypnotic state I was in. It didn't have to matter

what I was doing or how I was doing it. It happened of its own volition and energy.

Suddenly, my hand stopped. It knew I was done. Then I sat in curiosity and enjoyed this playful, magical display of abstract. In the lesson, there was a series of questions I could ask myself in regard to my creation. They seemed a bit redundant, but I grabbed a pencil anyway. What did I have to lose? I was in a zone of feeling absorbed. I was feeling pleasure for the first time in a VERY long time. It was tapping into a part of me longing to get fresh air. "How long am I gonna be stuffed down here? How long can you make it topside without me, without your core? Do you feel yourself faltering? Do you want something more?" My psyche was asking.

I did want something more, desperately. I felt crowded inside of myself. The crowding left my throat choking, and it felt heavy, so heavy, to carry around. I had stuffed the dismissed parts of myself down there into the shadows. My loyal little girl had dismissed herself in order to keep her mother safe. My young lady stopped her own life to care for her mother; she bore witness to the constant suffering and held a steady, emotionless stance in order to keep standing so close. My woman who had a family and raised children while sitting diligently at her mother's sick bed, held onto her mother's hand one last time, stroking her hair into the afterlife. The thing

she had fought so hard for, gone. My woman who had carried all of this and didn't know how to fit grief on top of all the trauma, so she drank for help.

These were the flashbacks of recognition I was encountering. This shadow diving was giving me recognition and release. The questions were asking me, "As you look at your drawing, how does it make you feel? How do the colors make you feel? Does anything disturb you? What surprises you about your image? What do you like best about it?" As I put myself in an open and thoughtful space, I found something new in me show up. It was thrilling to be acknowledging something deeper inside of me. This intuition I have always had an inkling about, but didn't know I could trust and utilize as a vital tool in life. It felt amazing to hear this whispering voice so full of wisdom and power. It told me I was valid, not just useful, but actually valuable. It told me that feeling exactly what I was feeling was an important clue which should not be dismissed because it was a part of me, and I am important. No matter what my experiences or how they affect me, I deserve full acknowledgement.

This process introduced me to my superpower, and a reflection of the unique way I am created. The important part of me was revealed in the way I am compelled to stand by loyally and serve diligently. I have an incredible abyss of empathy. I get endlessly lost in my lim-

itless capacity to feel for others. It can leave my stores depleted to almost nothing.

I wondered in the aftermath of all the trauma, why my brother still stood so steady and true, whereas I felt like a deflated nothing. I constantly wondered what was wrong with me, why I couldn't handle everything that happened. Comparing made me feel deficient, like something was missing in me. I did have enough sense eventually to tell myself to stop comparing. Perhaps we were just different and processed things differently.

I admire so much how Adam can simply take things as they come. He is accepting in his heart and letting everything simply be exactly as it is. He is present. It makes him steady, a solid figure who is deeply loyal and dependable. His heart is wide open and available. If you come to him with your truest self, you will be utterly embraced and supported. It's beautiful.

I process things in a deeply complex way. I am trying to make sense of the universe, infinity, eternity, and humanity. I am placing these deep, intimate moments into a perspective of the realms. I am not quick and simple. I am slow and thoughtful. I needed time to process all those heavy experiences. Instead, they just kept coming at me like bullets. I feel things deeply and intensely, bending towards the empathic spectrum. I had shut off making sense of anything.

I lost the ability to find context for my experience. Then I became stuck in a loop of horror memories, manifesting in nightmares and triggers. PTSD.

I found myself unable to make sense of reality. I was living in the gross and gory, suffocating upside down. It looked like I was right side up, but I was between worlds, haunted. Knowing what was real became an obscure, indecipherable thing. I was separated from myself.

Facing Futile

I WAS AT the beginning stages of learning how to hear and acknowledge my emotions. The expressive arts had opened the door to this new world of communication. I had begun the process of unraveling the layers I had not allowed to be seen. The view through this door alighted in me a hope for feeling something different than the daily choking, and the giant, invisible thumb pressing down on my head. It dawned on me that I didn't want to live like this anymore. Somehow, with an empowered thought, I figured out I didn't have to. A belief came that I should be able to enjoy life again. I had no idea how to understand what it was or where it came from, but I dug my heels in with determination. No matter what, I would find out! What was life worth living

with this twisted *Hunger Games* view? It is a sick joke, just waiting to heap horror after horror upon you. Don't let your guard down for a second, it is out to cut your throat and take you out at the knee-caps.

The learned helplessness I had gained through repeated negative experience kept me from accessing positivity. This was where the apathy and the lack of empowerment came in. I had concluded that nothing I did mattered. It is a very short step from, "Nothing I do matters" to "I don't matter."

That was my despicable view of life. Nothing I do matters. I don't matter. No wonder everything felt so terrible. I just didn't know how to get rid of this default view I had acquired. How would I shift and transform something like that? I saw an exciting potential in imagery journaling, this tool that I had developed in my arsenal.

I sat down to my large art journal with the intention of uncovering what I considered to be a deeply flawed paradigm of life. I wrote my intention on top of the page, "What does my paradigm of life look like?" I closed my eyes in breath, opened my eyes, and watched my hand work. My hand chose the colors of black, brown, and grey to represent. The page was nearly shapeless, just a haphazard mess of scribble and a thick covering of mottled colors. It was a deeply penetrating cover of morbid darkness. It inspired

thoughts of complete and total annihilation. Except for the parts of brown. I pictured earth as a small sense of grounding.

I didn't feel discouraged or dissuaded from my picture, rather I let myself be inquisitive. I looked at this as a starting piece in laying the groundwork to see where I was beginning from. "OK, this is what I have to work with. Let's go from here."

I reflected on my drawing and spontaneously wrote. There were a lot of words about anger, bewilderment, betrayal, the teasing and torment of death, devastation, crushing, and being spent to the bones. There was also the brutal proclamation that, "I can't trust God." I wrote in conclusion, "This darkness has permeated to a tremendous magnitude of my way of seeing the world. I search and look for light and beauty with all of my might, but I am still fighting this pervasive cloud of deep darkness my experiences have produced."

On a new page, I wrote another intention for a hope and possibility of a new paradigm of life and once again watched my hand. This time, an exquisite, colorful flower came popping out of the earth, unique and captivating. The best part was that it was coming out of this dark, brown earth. I saw how my foundations could be transformed to fertilize something spectacularly new. Hope and inspiration had arisen out of the mottled mire.

> *"Your intention to release the emotion and the symbol*
> *that represents healing will consciously and subconsciously*
> *replace the image of the old emotional wound.... Activating*
> *your sympathetic nervous system to respond with healing*
> *endorphins."*

– Visual Journaling Canim & Fox

I began to see this really clear vision of a mountain of rubble standing tall right in front of me. I was looking up and staring. I had absolutely no clue how to pick apart this mountain I knew was blocking my path that was utterly full of sorrow. Oddly, I did not feel overwhelmed and discouraged. I think I was so encouraged by being able to have a clear, physical view of what I was facing instead of the obscure, invisible weight hanging over me all the time. That's because I was being intimate and present with myself.

It was time to reconnect with my therapist. I was ready to do whatever it took to dismantle this sorrow mountain, and I knew that my therapist could help reveal the truth. I felt empowered with resolution and choice. I would tackle this mountain of sorrow because I was determined to enjoy and participate in my life again. I was choosing to.

My therapist helped me to go down the staircase into my heart to identify the rules I had made for myself as a little girl. I saw the

scared little girl who had to figure out how to make sense of tragedy and who learned too early that life is not safe. I found myself tucked way back in a dark hallway of my childhood house. The hallway seemed to go on indefinitely with no light penetrating its deeper recesses.

"What do you see? What are you experiencing?" my therapist asked. "I can't see anything. It's blank." She continued to talk me through the space I was in, taking me deeper into my heart until I could see, could feel and find a bright, illuminating light to penetrate through to me. I sobbed for this deep part of me lost, hidden and scared. I could feel the light surrounding and holding me. I was acknowledging the rule I had made for myself to stay invisible which could now be broken and reforged. I no longer had to make myself small and undistinguishable from my surroundings and void of needing anything, blocked from sharing my emotions. I saw myself as precious, and I held myself tenderly in that moment. I could now begin the journey of recognizing the importance of Andrea Marie Pardue. I could let her be seen not only to myself but also to the rest of the world.

Showing Up

PPARENTLY, ALL I have to do is show up and eventually, over time, something amazing will be created. All it takes is showing up. How do I show up for myself? I am working on that. My husband told me this morning, "Andrea you are important and valid." I was feeling insecure and having a hard time. Those were the exact words I needed to hear as I was feeling slumped and dejected by life.

Like clockwork, at the same time each year, I feel the haunting reminders. It starts with my birthday where it is impossible to not keenly remember the one who brought me into life on this Earth through her love and nourishment. There is a terribly deep pang where she is missing. Right after that, it is my mother's birthday

and a few weeks after that, her death anniversary; they are all neatly packed into a three-month span. By the time I get to Christmas a few weeks later, the thought of celebrating a holiday turns my stomach. I hit January in a fairly deep depression, and I just start to climb out of that when Mother's Day comes and smacks me in the face.

Maybe there is a better way to do it. Maybe it doesn't have to be so hard every year. Or maybe that is just the way life goes, and I shouldn't try to make it different but rather embrace it for what it is. I call my brother on his birthday, and he sounds utterly dejected. He should. He should feel exactly that. Maybe I spend too much time trying not to feel instead of letting myself actually feel because losing your mom really fucking hurts. I shouldn't pretend that it doesn't. I should melt into the deep sorrow because it's not going away just because I ignore it. The ignoring will suck essential lifeblood out of me.

I will also feel the fullness of the pain if I go down into the center of it. However, I will feel its power as well. I will feel confidence and possibility in myself that I could never have known was there if I had ignored it. I have compassion. I have empathy. I have innocence that is sweet and should be honored. I also find this tremendous authority I can claim. An intimate space I encounter that weaves and participates with creation.

I think I give God too much credit for taking control here on this Earth. I think I forget how much domain She has given us over it. I never understood, while my mom was sick, how God was or wasn't intervening. I was supposed to pray she got better, pray she came out of it, pray she could eat, pray she didn't throw up, pray the doctors could figure out what was going on, pray she made it through surgery, and eventually pray that she would die because all the other prayers weren't working, and the suffering was too much. It never made any sense because it wasn't a game. She was just sick because she was sick. It wasn't a matter of doing things right or wrong. It surely wasn't a matter of praying hard enough, or sincerely enough, or praying for the right thing. In life, we get sick and it's difficult because that's the circumstance. I just do the best I can with that. I can't change it or maneuver forces around to make it different. I can accept it as the way things work.

Shitty stuff happens, but I still get to choose how I encounter it. I don't have to be a victim. I have authority. I can plant the seeds and watch them grow. I can show up and see what happens. I don't have to be afraid of not knowing; I get to enjoy the fun and messy process of making my marks. Knowing that every mark I make is exactly right. It means something important. It came from something important in me. Whether it was from tiredness, curiosity, resolution,

whimsy, audacity, joy, or anger. Or just the mark I needed to make to learn how to make the next important mark. I get to be afraid and do it anyway. That deep creative part of me that wants to participate. All I have to do is show up.

Revealing Intuition

I AM SHIFTING my language from 'I have to', to, 'I get to', awakening my ability to desire and letting those desires be recognized, validated, and pursued. I am learning how to confidently use my voice to advocate for myself. It is being reiterated to me how willfulness can be so important. It is a defiance against a former container that has put me down, condemned, or disparaged me. I want to be tenacious.

These attributes can many times have a negative or undesirable connotation, but I am thinking they are wildly fantastic used in a vein of freedom for self. They end up giving and serving because it is my unique power revealed and shared in all of its glory.

I am ecstatic with gratitude in getting to write, draw, paint, and create. I am compelled to share with others those things that fill

me with a well-spring of energy that comes out of a deep source in myself.

I even wrote the first draft of this book on a manual typewriter. Not because it was efficient or recommended, but because every tangible letter I pounded out gave my heart a ping of delight. I didn't care how much extra work it took; it filled me with joy, which fed my soul exponentially. I didn't care that it wasn't logical, that it might look strange, seem eccentric or ridiculous. It was mine to love and be confident that I was doing right by me. I got to do that without questioning in the rational. It was actually important that I wanted to write my first draft this way because it reflected the things I value deeply. It required engagement of my senses. The bit of extra effort it took of me to interact, be present, and available was important. I got to dismiss what I thought was required of me or how I thought things were supposed to be done. I got to invent the important and unique way that gave me full expression. I was still utilizing the wisdom and expertise of so many others as inspiration, while also remembering that I have an important style and contribution that should not be missed by doing what I think I am supposed to.

I am peeking into my intuition. I am giving space for that intuitive voice to have a louder more visible platform because it can be rather subtle or meek, like a gentle nudging. My intuition is not a

forceful thing. It is more delicate and intricate. It is more fluid and springing up spontaneous. It arises because I have given it a safe and spacious place to do so. It is not trying to get something from me but only wants to give, generously. If only I will listen and quietly pay attention, undistracted and still.

It can be hard to know how to sit in the stillness of my mind and wait for it. Perhaps there is a longing for that more than ever as I find my attention demanded of in a constantly stimulated daily life. Something is always dinging and alarming and pinging for my attention.

There can be deep renewing rest of the soul that invites curiosity, stillness, and insight. I often have the nagging feeling that I am made for a slower pace. A more thoughtful pace. Less controlling and manipulating things, less rational, and more in tune to the rhythms that nature would dictate. Less efficient and more still. More quiet spaces for my tender, delicate insides to process - unsuppressed, unhindered, un-detracted. Perhaps a balancing out of a heavily reasoning and stimulated culture.

Reclaiming My Human Soul

I AM WORKING on building up the muscles or ability for intuition to form and speak, so I can confidently use my voice to advocate for myself and others. My intuition is something that is true without evidence or proof of it. It is the ability to understand something immediately, without the need for conscious reasoning. It is a direct perception of truth. My rational mind is always looking for a problem to solve. It needs and wants a problem so it can do its work to solve it and move onto the next problem. Intuition lives in spaciousness and possibility. It threatens my reason because it is free and unconstrained. It is not black and white. It invites creativity, beauty, and reverence, the unknown and mystery. It honors the most sacred parts of life. It is a beautifully intimate friend, full of wisdom

and insight. It opens doors and leads to new and exciting paths. It invites. It wants a witty frolic.

The rational mind is cold and single minded. It tunnels into one purpose only and is closed to possibility, only determined on its mission and elimination of the problem. It is useful but cannot be the only mode of operating. It's like walking down a dirt path focused on the lines that confine the path, making sure the way is clear in its borders. Forgetting to look up and stray out into the wild field of surrounding flowers. Discovering, smelling, learning, and partaking from deep inside of me. Arousing something exquisite.

I want the wide-open fields of gorgeous possibility.

How can I use my intuition as my primary source of operating? Then bring in the rational mind to problem solve through implementing intuition. First, I go exploring in the field of flowers with abandon. Then I spot something that triggers deep delight in my soul and heart and being. Creativity. What do I do with the revelations? Where does it fit? How do I express it in tangible form?

I don't know if what I am saying makes any sense. It's why I generally don't speak. I figure I have this abstract language that is indecipherable to the general public and potentially detangled from reality. Or maybe, I just understand reality in a different way. I can get pretty far into disorientation in my own singular world

sometimes. I figure my ideas don't exactly mean anything, aren't worth anything and most likely are totally irrelevant to the world at large. It's my insecurity that keeps me from taking up my rightful space of visibility. It keeps me from knowing that I am essential.

I finally got brave enough to start using my voice and experiment with sharing my ideas. Then having the gall to actually write a whole book just about me. That is pretty brazen. Who do I think I am? To be honest, the last thing I have ever wanted was for others to know my deepest most personal and intimate thoughts and experiences. I am an extremely private person. My own husband can barely get even basic information out of me many times. Those are my thoughts and my ideas. They are mine and not for public consumption. I could easily be one of those people holed up in a remote cabin surrounded by paper and books, muttering to myself. I can be very possessive of my inner world, like a dragon in a lair guarding its treasures. My thoughts are my treasures.

So why am I writing this kind of book for public viewing? Because I feel compelled. Some deep source inside of me, desire, longing, and compassion, compelled me. A force and energy beyond myself. I am compelled to be gutturally authentic. If I am going to reveal myself, it can be nothing but my most candid, raw self. It's the only language I know. I am deeply in tune to the genuine. That's why

I believe I felt so tortured by my own self for so long because I was not being genuine to myself. It got to the point that I could barely stand being in my own skin. "Who is this fraud trying to pretend to be a person?" I said to myself with disgust. That is why the discovery of expressive arts as therapy for healing was so profound for me. It opened the doors to the possibility of me.

As I am finding myself and tapping into my essence, I can't help but feel compelled to open up in new ways to share and participate. One of my deepest longings while in the pit of depression was to be able to function and participate in life. It must be at the core of who we are made to be as humans. We long to connect, participate, interact, and affect one another. It runs in our veins. Even with the recluse I often long to be, I desire intimate human contact. I already feel connection just by putting myself out here like this on the page, as uncomfortable as it may feel at times. One of the things that enlightened me to be brave enough to write came from all the times I have read a book and afterwards thought how grateful I was that the person shared themselves so I could be inspired and encouraged by their story. I could not refute the revelation of that.

It's like something I keep discovering with spontaneous imagery, doodling and mark making. The idea comes to me that every mark I make is right. No matter how messy or beautiful, silly, profound

or ugly, every mark feels right and true. It came from me, and I feel proud to have made that mark. I see it in everyone I do expressive arts with. Every mark means something and is important. Every mark brings meaning and insight, even if it is strange or forbidden, it is still right because it is true.

You should try it. Grab a piece of paper and a pen. Close your eyes with your pen positioned on the paper. Using your other hand, feel the features of your face as you draw yourself with your eyes closed and without lifting your pen from the paper. This takes away much of your inhibitions and all you have left is to sense through touch with a free exploration of yourself. Nothing you do is wrong. It is all right. It is a beautiful representation of something inherent. Now try another drawing with feeling your face but with your eyes open and not lifting your pen from the paper. Let your eyes and your touch be your guide. Be messy. Be irreverent. Explore. Play. Do some coloring if you want.

Here is one of mine. I would love to see yours if you want to send it to me at andreapardue44@gmail.com. Tell me what it means to you.

I love this exercise because it lets me be without having to try so hard. I don't have to make things happen a certain way. I am not confined. I can do all kinds of things in different ways and still be right. There is more than one way to skin a cat, as they say. That's gross.

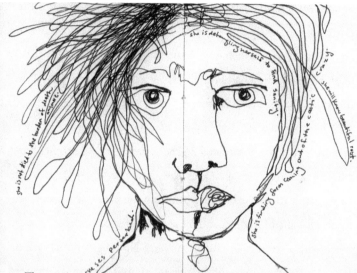

This realization has been the most unbelievably liberating thing for me after being so long in the role of caretaker and always having the stench of death around me. My baseline of dire, and desperate vigilance, and the futility of trying so hard to ward off death. Then, when death really does come, the grief drills so hard into my soul, creating this lost land of incoherence. But I can keep stepping forward, even in utter devastation because babies need to be nursed, toddlers need their diapers changed, mouths need to feed, and minds need to learn the alphabet. Houses need to be clean. Scratch that. You can actually live in a dirty house. Especially if the world around you is obscured by a thick, hazy fog. Life requiring the effort

of trudging through molasses. That joyless existence eventually saps even your will to live no matter how many beautiful little faces are depending on you.

My discovery of reclaiming my human soul was a miraculous world I was determined with every fiber of my being to delve into. I found energy and insight there that told me I am important. I matter. I am unique. I get to show up for myself. I get to take up space. I get to exist. I get to be sad and feel deeply wounded. I get to say how awful the nightmare of watching my mother suffer was. I get to claim how much I choose to sacrifice for family. I get to be angry. I get to question God. I get to not have to pray for what I think I want. I get to take a break. I get to account for myself. I get to sit in a long deep sob because I lost my best friend my mother, and it aches to the core of me that she is gone. I get to hold myself in a deep compassionate embrace for as long as I need. I don't have to sacrifice because I think I am supposed to. I get to deeply rest.

Losing My Mind

MY THERAPIST TOLD me that losing a parent through death is a form of abandonment. This resonated with me and gave me permission to feel what I was feeling: left behind. I had been traveling on life's tough road with someone so close and they just up and disappeared. That is the completely bizarre thing about death. It is the ultimate vanishing act. It is utterly confusing to our psyche.

It took a year for my dad to actually figure out that she was gone. He sat on their sailboat where they lived and waited patiently, diligently every day for her to return. He said, "It feels like she is just at the hospital again and I am waiting for her to come home." After almost exactly one year, he said, "I don't think she is coming back." He sold his boat and moved to Texas with us.

I saw myself having survived a long and cruel journey with chronic illness. I was withered and wasted. I pictured myself scrawny, cheeks indented, hair straggly, and a malnourished body covered in filthy, ripped and tattered clothing. When mom disappeared, I sat down on the dirty roadside in confusion. I couldn't figure out how I had just spent so much of myself. My loyalty was left in a torn and tattered state.

I'm proud of myself for standing by her side even though it has taken a gigantic toll and that I have sacrificed so much of what I could have pursued for myself. I have a tremendous depth of knowledge about love, sacrifice, and loyalty. I know intimacy and being willing to stick by each other's side no matter how hard it gets. We are not exactly made to experience that much suffering and trauma, however. It really fucks with your brain. It felt like it created all these short circuits.

That is what it felt like for me after experiencing decades of tragedy and crisis. Parts of my brain started shutting down. I have a loving, faithful, gentle, patient, and understanding husband that stood by my side, even as he watched me lose my mind in a state that looked suspiciously like mental illness. I was stuck in a reliving loop from hundreds of scenes in crisis.

I would be in a group of friends and feel this thing start to overtake me. There were too many voices, too many bodies, too much

motion. I felt paralyzed with panic. It was all coming at me and there was no place left inside of me to process any stimulation. The only thing left to do was escape. I retreated to an upstairs bathroom. I curled my body as tightly folded into itself as it could. I used the wall and floor to support me. I was breathing heavy. Frantic tears were coming out of my eyes. I could hear sounds coming out of my mouth, like a moaning or gasping. I could only get one word out, and I heard myself repeating that one word over and over again. My hand, without my consent, found its way to my head and would tap, tap, tap. It freaked me the fuck out. I didn't know how to get out of this strange place I found myself in. I didn't know this freaky person that I had been transported into.

Those moments of feeling so helpless and out of control are some of my most painful memories. I felt so abandoned by myself. The experience of PTSD was another layer of healing I needed to encounter. I had healed so much in the creative reckoning for myself. Still, there were deep trenches of trauma in my brain. I was learning how to be generous and compassionate with myself without hesitating or questioning. I would accept the healing that was offered and available to me.

In Loving Care of Family

I FOUND HELP through Transcranial Magnetic Stimulation (TMS). TMS is a treatment that helps revive a brain that has been atrophied or overstimulated from depression, anxiety and trauma. I was introduced to the treatment by my generous and loving Uncle Tad who called me one day to see if I could come and stay with him and Aunt Marie for a week while he gave me TMS treatments at his office. He knew of my depression and anxiety struggles.

TMS is a noninvasive procedure that uses magnetic fields to stimulate nerve cells in the brain to improve symptoms of depression. (mayoclinic.org)

The first treatment felt like an instant burst of energy. All of a sudden, I could think clearly. Before this, I had been feeling like

I was always trying to think through molasses. The brain stimulation gave me a clarity of thinking, which produced an actual physical energy to function. I could focus better. I had been living under the handicap of extreme mental fatigue for so long. I had come to accept my limitations. I couldn't do very much. I had to move slowly and understand my limits. I could only run one errand if I was doing good enough to leave the house, or I would find myself in a panic from the overstimulation and fast pace of the world around me. It took a tremendous amount of effort to focus on each task I attempted.

Driving was my biggest challenge. The fast pace sent constant electrical charges through my legs. After a short trip, I would need a long time of recovery at home before I could face anything again. After social engagements, I needed days to recover my energy. I sort of hate remembering having to live like that. I ache for myself because of how much effort it took for me to live and function. I realize how brave I was to keep pursuing life under those conditions, and not giving up. But I think it also makes me profoundly grateful now in being able to participate and function in life. I do not take for granted that I get to leave the house whenever I feel like it, see friends, run errands, go on fun adventures, host, and facilitate. The joy of participating is life giving. I have so much compassion for

those struggling under the burden of anxiety, depression, PTSD, and other mental illnesses. In my mind, you are automatically the bravest person ever to be living under such conditions.

Uncle Tad and Aunt Marie generously opened their home to me. They insisted I sleep in their screened in porch made into a bedroom. I felt the fresh night air as I slept. I woke to the sound of birds, and when I opened my eyes, a small group of deer greeted me with the first light. It was magical.

When I got up, I sat on the porch alone with my thoughts and my coffee. The deer grazed, watching me with a trusting skittishness. I experienced that beautiful time of dawn when the birds wake and peak with song together. It filled my heart with grateful anticipation.

Aunt Marie served us egg and potato casserole and grapefruit, then I headed out with Uncle Tad for a day of treatments at the office. It was not lost on me how much Uncle Tad did to fit me in between his clients throughout the whole day for a week. I could feel his excitement and caring in his generosity and compassion.

Uncle Tad and Aunt Marie are not my relatives by blood. I am connected to them through my husband, but they made me feel more akin to a daughter. I felt so loved and cared for in the ways they served me that week. Not having a full set of parents anymore, this touched a deep and longing part of my heart, opening up a

healing. I felt welcomed and embraced. It felt like it mattered for me to get help and to heal. If they were abundantly willing to serve me this way, I must be worth something. I must have significance to count for this tender loving care. Maybe it's partly that I had spent so many years taking care of everyone else. I forgot what it felt like to be taken care of. I forgot what it felt like to be advocated for and put a priority on what I might need. This place of safety and acceptance opened me up in a new way to receive.

Bringing a Brain Back to Life

THERE ARE MULTIPLE areas of the brain connected to each other by neurons that fire on and off electrically at different rates. This rate varies from person to person and depends on level of activity. The depressed brain becomes overconnected to a default mode network that is like being in a neutral state. In this state, the brain is judging what the demands of an ordinary task will require. In depression, this part of the brain is overpowered and overconnected to the idle part of the brain, making the ability to discern the difficulty of something seem increasingly hard. For example, when I was in a state of depression, I may look at a pile of laundry and that idle part of the brain that I am overconnected to deems the act of folding laundry to be nearly insurmountable.

It's in neutral, therefore, doing as little as possible.

TMS helps detract or disengage from this deeper, idle part of the brain by increasing the blood flow to the subgenual cingulate, which plays an important role in regulating emotion. Degeneration in this area correlates with depressed mood. (pnas.org) The subgenual cingulate also has the ability to increase function of networks. The result could be to lighten and smooth out my ability to approach tasks. I experienced the benefits of TMS as a sharpness or clarity in how to face life demands, making them seem clear and easy to do.

There is still a lot of confusion surrounding how the brain and TMS work, but it is a confusion at an increasingly sophisticated level.

I sat in a dentist-like chair wearing a cap marked with my measurement strapped precisely onto my head. The electromagnetic transmitter attached to an arm was positioned to a targeted spot on my head. I held still, and the treatment started with intermittent pulses penetrating to about an inch into my brain. It didn't really feel like a zapping, more of a tapping inside of my head. Sometimes it felt rather soothing. Stronger pulses felt a little like it was grabbing my brain. At most, it felt uncomfortable or intense. By increasing the blood flow to the target areas, it increased nutrients and oxygen, instigating growth. Genes and neurons were being ignited and turned

on. Little bitty branches and connections between neurons started to reveal themselves. Grey matter tendrilled out in sophisticated delicacy. It felt like something was being enlivened inside of me, woken up and spreading into new spaces.

Between my treatments, I would sometimes have an hour or two. I spent nearly every chance I had hiking the miles of trails in the hill country forest that was just down the street. I remembered again just how much I love hiking. The exertion and the ever-changing scenery was glorious as I made each turn and climbed atop each hill. I felt the pushing, pulling, and stretching of each muscle, slick and contracting with the effort and momentum to climb and procure new heights.

Hiking is the space where I have encountered God the most candidly and intimately. It is something about being grounded and feeling held by nature and the wild. I really talk to Her. I open up to the bottom of my heart, letting Her access me more intimately. I feel seen, touched, and filled. When I wasn't hiking, I was doing art therapy. It was a beautiful time of interior.

When we got home at the end of the day, Aunt Marie had a lovely meal set on the table. We debriefed after dinner as we sat out with a glass of wine by the fish pond. I got to go to bed early, my favorite, and fall asleep to the night sounds. I read the words in Jenny Law-

...ng and candid coloring book, soothed by the expressions of ...ng ok to recognize our hurt and our hard.

Returning home, I got to encounter life in a new way. With a brain that could process and function, instead of fighting through molasses to think. There was this new spark of firing that had started in my brain. A new energy to engage. It felt strange to encounter regular daily life and be able to make quick and easy decisions even with simple things. After years of depression, every aspect of life had become this nearly insurmountable mountain climbing. The simplest tasks left me feeling blank and paralyzed, exhausted. I watched my friends around me functioning, getting things done and going out. I barely dared go to the grocery store. If I could survive the panic-inducing, and overstimulating task of driving the five minutes there, then the daunting of seeing rows and rows of shelves. Then I would need to make decision after overwhelming decision. As soon as I walked into the store, all the stuff confused me, and I would forget why I was even there. I only went to the smallest grocery stores to minimize overstimulation. Costco? Forget it! How come I couldn't do all those things? I had been taxed to disfunction from accumulation (adrenal fatigue).

All of a sudden, I could do those things again with ease. It felt like a glorious gift. I had basically accepted my molasses brain and

learned to live with and accommodate for it. It left me rather limited in my options, but I had learned how to manage. This unexpected ability to engage with life felt glorious. I found myself going out spontaneously just for the fun of it. I kept thinking, "No wonder people enjoy life if this is what they get to do!"

I did well for awhile. I was growing and learning by addressing myself through the expressive arts. However, I continued to find myself stuck in this residual loop of trauma memories. Six months later, I had a second stint of TMS therapy at a local practice when the deepest parts of my victim mentality revealed themselves in full force. Along with PTSD symptoms, I found myself stuck in these loops of horror pictures from medical trauma that just kept playing over and over again in my head. My full-blown reality was, "Life is futile." I had thoughts like, "I would be doing us a favor by burning us all down."

I had enough clarity and presence of mind to recognize that this thought is not okay, and I should get immediate help by checking myself into a mental health institution. I was learning how to problem solve and use a rational brain to handle intense and irrational emotions.

I didn't have to be afraid. I just needed help. The only problem I was having with the mental health facilities was their heavy use

of sedation and drugs. Which can be fine temporarily, but I did not consider it to be a good long-term solution. I was willing to do whatever it took to be okay though. Quite frankly, it sounded amazing to be "checked in" and taken care of. I was so exhausted from carrying this burden of futility. I had already been fantasizing about going to a padded white room for years. And yes, I do recognize this would be a sign that things were not okay inside.

I was able to talk to Uncle Tad, and he recommended a local doctor that does TMS treatments where I live. We made an appointment with Dr. Gardener. I felt a soft, melting relief from being in her care. She was so gentle and insightful. Just the questions she asked me in our first interview made me feel seen and understood. She was asking exactly the right things. She knew. She knew how the memories of horror had been flicking through my brain on repeat. A loop of reliving. "We are going to take care of you Andrea," she said with compassion. "It doesn't have to be like this for you. You have severe PTSD."

It was the first time someone had so confidently validated that for me. I was mostly thinking I was making stuff up, or I was wrong, or there was something wrong with me for having a hard time. As if my experiences shouldn't be difficult and painful for me. I hadn't let myself acknowledge that some really hard and gruesomely shitty

stuff had happened over a very extended amount of time. I should feel this way. I get to feel terrible about it. I wasn't expected to just take it and be fine. I get to be human. I get to be hurting and heal. I get to say that the situation was really fucked up, and I don't know how to make sense of it. I forgot or never knew how to have compassion for myself.

I also had this thing running through my brain that it wasn't that bad. I didn't have it that hard. So many people have it way worse. I should only be grateful for the things I do have and not have feelings about what I don't have or have lost. Somehow it would be a betrayal if I say how sad I was about missing out on having a healthy mother. It was like I didn't allowed myself to have feelings about that. Just by admitting how I felt, I did not negate how much I still got to enjoy my mother and felt close to her in other extraordinary and special ways. I learned how to sacrifice without regret, but I could also feel sad about missing out on a lot of life experiences because I spent so many years as a caretaker and became so deeply drained. Being sad about that doesn't take away how grateful I am that I could be there for my parents. I get to hold both within my heart.

A Boost Out of The Loop

A COUPLE MONTHS before getting treatments with Dr. Gardener, I had done an intentional expressive arts activity to address the futility I was feeling about life and how desperately I wanted to change that paradigm. The one with a dark scribbled mass on the page and then the exquisite flower bursting out. I had also done a portrait that revealed the anger I felt about this futile paradigm and the desire to experience beauty in my life again. I think that intention and the willingness to pursue the deep dark crevasses of myself opened the door to receiving fully this gift of healing I was about to experience with TMS for my anxiety, depression, and PTSD.

I simultaneously started scheduling weekly appointments with my therapist. I had barely given myself permission to go to her be-

cause I didn't think I was worth all that money to be taken care of. My first acts of accepting and advocating for myself was to start a full treatment plan with TMS for as long as it needed to be and go to therapy for even longer than I thought I needed. Enough of this bullshit that I don't get to be taken care of. That I don't get to have help, that I don't have a good enough reason for feeling destroyed. No more thinking that I just had to take it alone. I was bone tired from holding it together for everyone else. It was my turn to let down and be taken care of.

My therapist would guide me deep down into the very bottom of my heart to see what was hiding there. I found a scared little girl deep back in a dark hallway. My doctor asked me to bring the girl out. I brought her a little way out of the deeper dark, but she was still hidden in shadows, guarded. I couldn't see or feel how to bring her out all the way. Something the doctor said melted and shed the last bit of harboring. I let go. I let down. I released the protective need that had served my little girl but only kept me stifled, hidden, lost, and unseen.

The doctor had me picture this brilliant light shining down on me that represented unconditional love and compassion. I was to hold my little girl and comfort her, accept her, acknowledge, and love her. Welcome her back. And I really did. I could feel myself in

my own arms. It felt amazing. I felt accepted and relieved. This was my first understanding in how to go into those desperately hurting and fiercely protected parts of myself. I gave acknowledgement and compassion to reckon with whatever it was that wounded and banished me. I gave this wound the credence that it deserved. To lament and cry for the sorrow of it and how it affected me. Reconciling and releasing. So that whatever part of me I had hidden away could once again be free to join me in present, real time life.

I even went so far as to invite that part and what it represents to join me again. The innocence and compassion. Letting it know that I want it to be a part of my life again. It is safe now. I had become hard and savvy in order to go down the trauma path I was on. There was no room to feel. I was too wise to life's cruel ways. I wanted lightness and playfulness back. I had felt so caged into this isolating hardness. I let my hidden mouse back in.

In my TMS treatments for PTSD, I had to make a script of a memory I was reliving repeatedly. It was excruciating to write because I was supposed to add in all these sensory details to really bring me back to the memory viscerally.

Here is one of the scripts that I used:

I am sitting in the hospital room with my mother. I see equipment and IVs. I smell sanitizer. The floor is shiny. I think my mother knows who I

am, but she does not speak with any sense. She has rejected the rest of the family thinking they are against her. I am the only safe space for her.

It was a bizarre scenario of reading my memory while my head was strapped to a machine, pulses going into my brain while I sobbed and gasped, and was pinned to the chair. Igniting the grey matter in my brain back to life. Growing, stemming, breathing life and nutrients into a fresh existence that got to look for a new way to thrive, dive, and penetrate into the mysterious extravagance of my brain. I could feel it growing like a tender new tree. Wanting life, and feeling relieved with the tendrils of growth.

I worked on really visualizing myself in the moments of my memory with compassion. I cried with sorrow for what I had experienced. I came up to myself in the moment of that memory. I told myself how sorry I was that I had to go through that. It was not okay. No one should have to be tormented like that. I held myself with deep and utter compassion. It was an amazing reconciliation of the memory. A recognition that it is over now. It's all over. It's okay now. I could also feel the pulses relieve the intensity of what I was feeling. Making room for a new pathway out of the one I had been entrenched in for so long. I felt lighter, tender and released. Available.

It was like opening a gateway to a field of possibility. I was gently lifted out of that entrenched trauma state and invigorated. I final-

ly felt myself have form and substance. Not this obscure drifting semblance of human that could barely feel the ground beneath its feet. Nothing tangible or real. Life feeling like a bend of nonsense. Suddenly the world around me was righting itself. I could smell and taste it, and if I dared, even touch it. I longed in my veins to touch life. I had felt so distant and removed from it for so long. Hijacked into this confined and tormenting space in my head. Ever protective. Ever paranoid at constantly perceived threats.

I would often close all the curtains in the house. I would lock all the doors and retreat into my room with the bedroom door locked as well and wear earplugs to escape the constant threat that life felt like. I was desperate for a respite.

The releasing of my brain's torment humbled me so deeply with gratitude. It would never be possible for me to take for granted the gift of a mind that processed, can delight, and experience joy. The ability to feel happiness. I'm sobbing even now as I write this with deep gratitude. "You mean I get to enjoy life again? I am supposed to enjoy it and feel passion and desire, excitement, anticipation, playfulness, and whimsy?"

I really do believe that it takes a good dose of defiance and willfulness to not give into the dire, hopelessness of depression, trauma, and anxiety. When I find myself, out of nowhere, deep in a hysterical

panic, stuttering, sobbing, and repeatedly hitting myself, I am utterly without a safe place to be because the biggest threat is inside of myself. It felt like a desperately helpless place to be. I was derelict. And out of a stubborn will to not give up, I proceeded each step forward in life.

There is a place for stubborn defiance to face hopelessness. This is where it is also about a stubborn belief in God while I am also accepting and contending with my humanity, like my mom's defiant belief in God's authority and sovereignty. I decided to embrace fully my humanity while also clinging with every fiber of me to delve into the force of God/Creator.

I think it was the fighter inside of me that refused to give up. My anger became an incredible ally. I will not relent. It has been a long journey of recovery. It comes in layers of healing. I would have a breakthrough about something, finding further liberation in my life, only to find myself a little further down the road hit by another unearthed piece that reared ugly in my face I had to contend with. I had the tools now to do the contending. I had built up my toolbox to grab every time I needed it. Because I will never stop needing that toolbox, I just get better and more efficient at using my tools when depression's grip comes over me.

I would feel so free and amazing in life, then all of a sudden, from a trigger, I would be looking up from the pit of despair again.

Fuck. How did I get back in here?!! I looked around, puzzled, and saw all these ropes hanging along the edges connected to the top-side. Scratching my head, I realized, "Oh yeah, I put all those ropes down all that time I was topside." I grabbed the nearest rope and quickly climbed out, able to continue on as normal. For a moment, I had fallen right into the center of the deepest, most familiar pit of depression, but I had built up my resources and just like that, I remembered that I have choices. I have clear paths to those choices, and I feel empowered to take them. I am not a victim of this life. I am a powerful, willful, and feral creature full of soft and gentle beauty. I have fierce determination and authority over this impossibly extravagant domain we call Earth. My home presently in the universe.

My Brother and the Olympic Peninsula

MOM HAD BEEN gone a few years when Adam and I decided to start meeting up once a year at one of our old haunts on Washington's Olympic Peninsula. We were reuniting after the long stretch of trauma and death we had experienced. I was living in Texas, he on Whidbey Island. It was a coming full circle to the adventure and play of our growing up together. We had both grown into our middle life, settling in with our own families, healing and recovering from the harshness life had thrown us. We were settling into the new life that the energy of our children brought, finding our confidence and place in this world outside of the urgency of trauma.

As teenagers, Adam and I would take off for the weekend to surf the wild, cold waves on the Olympic Peninsula. We were poor and

adventurous. Our overnight accommodations were our car parked in the sand near the beach. We built a fire and slipped into our sleeping bags right next to the warmth, letting the sand contour to our bodies. We met other surfers out there and would set up a camp together. They thought it was funny in the middle of the night to throw a log on the fire where I was snuggled next to the warmth and watch me squirm away while I slept.

These trips were a rite of passage for Adam and me. We were joining a bigger community of the world. Adventuring and discovering for ourselves what life had to offer.

Adam and I picked one of our favorite spots on the Northwest to rendezvous on the Quileute Indian Reservation in La Push, Washington. I've always thought it was amazing, and I am half in awe of the sacredness of this tribe letting us on their land, actually inviting and welcoming us non-natives. It feels like a sacred privilege to partake of their territory. Who do I think I am to presume upon their hospitality? This beautiful rich land in which my heritage does not even begin to know how to revere. Their culture has made this a spiritual and holy land. Something I can only wish to begin understanding.

There is a resort on the beach in La Push with houses, a lodge, and very simple A frame cabins. You can choose a cabin with or

without hot water. Every cabin has a cozy wood burning stove. There is a damp chill in this area year-round. The towering evergreens keep it shaded. In the forest near the beach, ferns thrive happily, and the grass is always a brilliant green.

This area gets about 140 inches of rainfall per year, producing some enormous trees. In some spots along the Hoh River, one could carve out the inside of a single tree to live in. Walking along the Hoh river trail among these giants was a humbling experience. I felt the density of the forest. The lush green growing out of everything absorbed sound which created a quiet softness. Ferns as tall as me whispered an invitation. I settled down into a quiet space within myself.

We settled into our cabin after the four-hour ride from the airport. Adam decided the surf is right, so he plugged into his wetsuit and paddled out into the crisp water. I decided that the forest was calling me. I had just come from an arid land, so I was starved for the lushness that all this moisture provides.

I stepped onto the trail just down the road from our cabin. I had entered a magical, sacred space as my heart alighted with a reverent excitement. Everything was covered in green carpet. It was soft and spongy below my feet and dripping with delicate, webbed mosses and lichens. I wanted to cuddle into a little nook of this forest for

the rest of my days. There was an absolute sense of peace. The wisdom of the forest; these ancient trees were like walking among the elders. They have been quietly standing on this earth for centuries. I imagined the history they could reveal to me, they did reveal to me, in their inaudible voices. I saw ghost logs everywhere. The way the new trees had grown around a massive, once visible trunk. I indistinctly heard their story of storms and clearcutting. There was evidence of their lives. Just like the bonsais on the ocean cliffs of Ft. Ebey were telling their story through their twists and turns. It was timeless in there and would take me many lifetimes to get to know these majestic giants. For now, I walked among them and absorbed their towering presence. I reveled in the fact that I got to be among them for those brief moments and that I felt the most not alone when I was with them. They were reassuring and comforting. They represented something long standing and solid. I have never felt so relaxed within my own skin. It's like they consumed all the space where my insecurities would like to be. Like everything is exactly as it should be.

I could tell the trail was nearing the beach as light began to filter through the trees, and the trail started to descend towards the water. Most of these forests are raised up on cliffs by the ocean. Their rocky edges sometimes jutting out into the waves. I stepped onto the sand

of the long, wide beach. Massive trunks had been carelessly tossed towards the back of the beach like enormous matchsticks. I often long to be present when these kind of winter storms and high tides so easily and playfully tousle the girth of these logs ashore.

Haystacks were jutting up everywhere. Some of them were right on the beach, and others were way out in the water. My new favorite thing to imagine involves picking a haystack a long way out in the water that I would like to live on isolated for a few months, just to see what it would feel like. Should I pick a flat-topped, grassy one or one that is steep and dense with forest and brush. They jut out of the water fearlessly, boldly, with sheer rock cliffs. I picked a flat-topped one really far out in the water. I imagined being dropped off there by myself with some simple supplies. It would just be me and this wild exposed ocean rock. What must it feel like to intimately experience the ocean and its weather, deeply exposed to its powers? I felt my passion and longing of curiosity. My throat was tight with giddiness and determination. I knew I sounded eccentric, but I didn't care. I was carried away with this imagination. My brother often makes fun of me for such ideas. My husband used to flat out refuse to entertain my fantasies. He is warming to my craziness though, humoring me a little bit. For me, this soul connection with nature feels like a purpose and affirmation for this life.

I wandered back to the cabin to meet Adam who was dripping wet and giddy. I wouldn't usually use that word to describe my brother, but the combination of cold water, and wave riding altered him. We had picked a cabin with hot water so he showered while I chopped onions to saute' for dinner. When the onions were brown and sweet, I added the ground pork Adam had brought from the pigs he raised for his family's meat supply.

Adam put another log in the stove, and we sat down to dinner and a warm evening of cards. We deferred back to our old classic of gin rummy. Our first day together ended with full bellies and fresh logs stuffed into the stove. The warmth relaxed us into sleep. Tomorrow we would continue our beach exploring together.

Third Beach

DURING OUR TRIP, my brother and I decided to hike Third Beach, a few miles South of our La Push Cabin. We hiked the 1.5 miles through the luscious forest to get to the beach. Then we hiked half a mile down the beach to get to the West Coast Trail (WCT). This part of the WCT is over 15 miles of beach and forest hiking. Some parts of the oceanside cliff jut out into the ocean so you must hike up the cliff and along a forest trail to get around it. Unless you are up for a hearty ocean swim.

The start of the WTC is signified by a long yellow streamer that is tied to a stick poking out of the sand. It is next to a sandy, wet cliff that is the start of the trail. At the trail entrance, there is a rope to hold onto to get up the first 100 feet of steep, mud cliff. For the next

100 feet after that, there are rope ladders with wood steps where it gets rocky and sheer. Trees clung to the solid cliffs. I wondered how some of these trees were staying upright. Their rock imbedded roots jutted straight out into the air from a vertical shelf; the soil that was once there had long disappeared. They only had the solid rock left to cling to. Ferns feathered out everywhere like plumy blankets.

After a steep switch back trail, we found ourselves flattening out at the top of the cliff. We turned our bodies to face the ocean view and simply cried. There was nothing else to do in such majesty. Wordless, expressive awe. We are humbled at partaking of this expanse of ocean laid out before us. Our hearts melted in the mystery. It was a salve. Audible sobs came from my brother. His strength and perseverance, his steadiness became so beautiful in that moment. I admired his ability to appreciate. His strength, his vulnerability, and humble abandon shone a purity of heart. His capacity to love, his willingness to sacrifice, and his loyalty was a shimmering energy and power. I felt so calm and assured in his raw presence. I was privileged to witness his candid underbelly.

We had been through so much together in this life. We had been true and good buddies. As teenagers, we played and adventured all over Whidbey Island. We risked and explored with abandon. Perhaps one of our tricks of one person driving at 40 miles per hour

while the other person hung onto the outside of the car window donning rollerblades would be considered reckless. Regardless, we had such wildness in our adventures together. Our young souls longed to taste every sense of nature with a feral abandon. We tasted a purity of being alive, the opposite of a slumped helplessness.

We had gone through the crisis and care of our mother together. I have never felt so bonded with anyone as I did with my family during our long persistence in crisis. Unspoken, we were loyally holding one another up. Our hearts tender, warm, and united together. Compassion and empathy surpassing many other points of life.

After mom died, it felt like a grenade had gone off. Everyone scattered. In our grief and shock, we all fell into our own rubble separated from each other. Our father sat on his boat for a year, barely acknowledging mom had died. Our phone conversations during that time went something like this: Dad would say, "Hi sweety. How are you doing?" Me, "I'm not doing so good. I've just been crying all the time." Dad, "Oh. What is the matter?" Me, "My mom just died." Dad, "Oh." Then silence. I would start crying, and then we hung up the phone as conversation was no longer possible. I was recklessly grieving, abandoned.

I think we all felt distant and alone in our grieving. Adam and I would try to talk on the phone, but we couldn't make sense of

anything. We all went to our separate corners to lick our deeply penetrating wounds and decide how to rebuild a life. I think our grief was blinding after surviving suffering for so long. We had all been so absolutely consumed with keeping mom alive that we didn't know what normal was. We didn't know ourselves anymore. We didn't know how to know outside of crisis.

I remember thinking how grateful I was that I was already living in Texas for a year before mom died. Far, far away from the memories. I was establishing flourishing friendships that I desperately depended on to get me through the next phase of grieving. One of my best friends lived across the street. She would come over regularly after my mom died to check on me. She would sometimes find me crumbled on the floor crying. She didn't have to do anything. She just said, "Oh Andrea." With this extraordinary, gentle kindness in her voice and put her arm around me. Relief would wash over me. I wasn't alone. Just having that witness to my grief validated and affirmed my experience. It could be okay. I got to feel this sad and this hard at losing my best friend, my mother.

Adam and I drifted into the newness of the lives we had created for ourselves out of the rubble. We had each picked best friend mates. We had each been friends with the other's partner before we had begun romantic relationships with our spouses. There was

a deeper flowing bond in all of our like heartedness, a quality that our souls connected to. The four of us, during our single days, used to rollerblade around Seattle at night, go to the ballet and backpack in the mountains together. There was a bond in our appreciation and loyalty for the adventure of life.

After death, in grieving, there is this prickly period where nothing makes sense anymore and suddenly nothing is bearable. Any grievance you may have had with the still living are suddenly blaring in your face. I connect all too keenly with the scene in Gilmore Girls, where Lorelai and her mother are berating each other after Richard's funeral. How typical is that, I wonder? It feels like anything good has just been destroyed, foundations obliterated. The only thing you see left is the unbearable and destitute. All the ways you have felt wronged in this life come suddenly bouncing out above the surface, like a beach ball you've been standing on in the pool. You've been knocked off the ball and it comes shooting out of the water.

Everything feels wrong. Death is so normal, yet it rips and tears the soul apart. I would sit outside and just ask, "Where did you go mom? Where are you? I can't find you. You were just here. Where did you go?" I would occasionally listen to the last voice mail she had left me (to torture myself to be sure) just to hear her tell me one more time how much she loved me and hear her asking with such

sincere interest how I'm doing and what is going on in my life. I felt so severed from her presence. The place she held for me in this world gone.

I still feel severed, but the ache is less acute. I can bare it more gently instead of feeling it seize my every inner part and collapse me to the floor. I will ache at missing her forever here. She feels so far away. Completely unreachable. Shortly after she died, my son suggested that we send a message to her through God since we can talk to Her and that is who she is with now. What a clever boy.

The Glass Ball

A s I WALKED along the West Coast of Washington with my brother, I felt that sense of belonging. This rightness that I had been dropped on the planet because I was supposed to be here. I am a beautiful part of this vast extravagant creation. It is grounding, being in the ease of nature. To hear the sound of everything commune in the quiet and the breeze through the trees, the waves crashing, the call of birds and the soft hum of insects. The sunlight that sparks on water, and the soft moss bellow my feet, the ferns tickling my arm. The sand shifting below the weight of my steps. Muscles the size of my fist resting in tidepools. Rock caves carved out of ocean waves only to be entered at low tide. My favorite are the waves crashing on rock walls. It's an explosive burst of celebration

that grips my insides. My eyes cling on for as long as the white spray will last, soaking up the celebration.

Along the vein of celebrating, during this walk, I spotted a glass ball. Japan has a large deep sea fishing industry. They started using glass spheres in the early 1900s as floats that attach to miles of fishing net. By 1940, glass was mostly replaced by wood, cork, and later with Styrofoam.

Apparently, there are still possibly millions of these hollow glass balls circling the currents of the North Pacific. There is a pattern of ocean currents that they follow in a circle until a big storm pushes them out of the current where they drift onto the beaches of Alaska, Washington, and Oregon. These hollow spheres have become rare to find. There are some hearty beachcombers on the lookout for them. Being in a remote spot gives one a better chance of discovering them.

For years, I had longed to find one of these glass floats. It felt like a special part of a journey to encounter. This little glass ball about the size of my fist has traveled for possibly a century, unharmed. I imagine all that it has encountered of the ocean storms, calm, and creatures. The most amazing part is that this delicate glass globe can somehow stay protected enough by the water's cushion to take fantastically phenomenal tumultuousness. I think I like how it represents our own crazy lives. We get tossed and turned, the rage and

energy of life blasts us with its worst, yet we stay protected by this mysterious cushion.

What is protecting us in this life? We are delicate and beautiful, yet resiliently strong. There is an invisible cushion. I guess we just need to trust it rather than resist it. Let those storms do their worst, washing over me with tremendous force. Instead of feeling the insanity, I can let myself go for the ride and know that I will be caught in a cushion. I don't have to control or resist, just go with it. Also, I didn't have to ignore or pretend that there is a big fucking storm happening, that I am in the middle of, that is vast and consuming.

When I spotted this little glass ball on the beach, everything inside of me halted. I walked with a magnetic clarity towards this small globe. I knelt down upon it, quivering as I pulled it towards me firmly. My brother walked towards me and watched as I held the ball up with tears streaming from my eyes. It was a precious gift given to me. It had made its way to commemorate a journey. I was humbled with gratitude. Adam beamed with delight for me. He had found his glass ball a few years back and knew the depth of pleasures that it held. This seafaring delicacy had found land after its tremendous journey. It rests outside of the tumult now.

Finally Feral

THE DESIRE TO become feral after a lifetime of feeling like a helpless victim of circumstances came to me swift, like a pre-storm breath. It was a spacious feeling. It held a defiance. My derelict self was finally in clear view, and it wanted to run and play. It was starved for a sense of freedom and voice. I was letting it out, and it was ready to experience its wild, untamed self.

I took my feral self camping, just me and the wild. I felt invigoratingly alive as the thunder shook the earth beneath me and the lightning illuminated fiercely. It was a glorious test of wild abandon and freedom. I let myself be encompassed in all that I exactly am. Not trying to conjure up anything. Pure, authentic, and innocent. I love that sweet nectar of innocence. It is delightfully frisky and unconstrained.

I had fantasized about going camping by myself but never had the guts to actually do it. I finally felt confident enough to try. The hardest and weirdest part was having to sit with myself so completely. I am a type that adores my alone time. It's often hard for me to get enough of it. I would say that it felt eerie and a bit uncomfortable to be so utterly alone. I was reckoning with the deepest parts of myself in the quiet, holy ease of nature.

I sat by the evening fire. Potatoes and sausage sizzled in the cast iron pan. Fireflies began their show in the air. I felt invigorated and keenly present. I became awash in the delights of nature's mystery. Behind the fireflies, in the distance, the entire sky began to flash with light. Slowly, the sky flashing came closer and closer until I felt the first few drops. I abandoned my fire to the sky water and got myself securely into my tent before the torrents and whipping wind came.

First the wind picked up its full force. I began to feel that the only thing holding my tent to the earth was the weight of my body. I was a giddy child being teased lovingly by something powerful and unseen. Even though I knew there was danger, I felt secure in an unspoken restraint. The precipitation picked up, the earth trembled below me.

For half the night, I could see the blinding flash of light while simultaneously feel the boom of thunder through my whole body. I

was waiting for the trees around me to be pierced with fire. I loved every minute of it. I could close my eyes and be in communion with this force. I was reassured by it. Confident in the strength of power. I intimately felt it being its full self. Feral, wild, fierce and authentic.

Why did this feel so amazing? I think I relished the magnitude of how much I was not in control. A reassurance. Perhaps I was discovering the definition of being grounded. I delighted in my humble state that gets to interact with this fierceness. A visceral reminder that I don't have to be the one in control. I don't have to try so hard. The pressure is off. Relief came in the force of this reminder. I can, in total peace, be exactly and humbly who I am. I don't have to conjure up pretentions of powers beyond myself. I get to simply be me. In all my quirks, discrepancies and playfulness.

It also reminds me that I am a force. I wanted to shout out to the world, "RECKON with me." I let myself be accounted for. Standing boldly upright and present. "I am on purpose!" The deepest desires of my intentions are ripe with wisdom. I only need to sit quietly, still, and serene in the space of my heart and hear its beautiful story. And claim that story. That vital and important story of me.

Visible Space

WHEN I DID the TMS with my uncle, he had me write a description of what I was experiencing in my depression and anxiety. One morning I got a text from him telling me he shared my words with one of his patients who was a mother and struggling profoundly with depression. He said she was encouraged and blessed by the story of my experience. It was just the candid guts of my struggles in persevering. I burst into tears when I read his text. It absolutely floored me and cut to a deep place in my heart that I had connected with a single other person so intimately, with impact, just by sharing my story.

I think it humbled me to realize how valuable and important my story is and how sharing it can bring healing and validation to others.

I was humbled that this small, little, seemingly insignificant Andrea actually had an impact on the world simply by being me and visible.

I still have to work really hard to believe that. I am growing in confidence though. I have shared a lot of my expressive arts therapy experiences with friends. I have had them, their parents, their spouses tell me how impacting it has been for them. I listen politely and say thank you and try to believe the significance of what they are saying. Why do I not believe? I wonder if I did truly believe to the full strength of this energy and power I am giving to others, how large could I become? How much space could I take up in a profound and glorious way?

My mantra lately has been that I get to take up as much space as I want. It reminds me of my value. It gives me a very expansive sense of freedom in this life. And it leads me to ask the question, "How much space do I want to take up?" When I was trapped back in the cage of depression, anxiety, panic, and PTSD, I felt constricted and limited, thwarted and tied away from everything around me. I began to long to be able to participate in what I could see before me. I wanted a place in the swing of everyday life. I was tired of sitting on the couch, in the corner, or locked away in my bedroom, paralyzed.

I often felt like I was inside a glass box. I could see everything in the world around me, but I couldn't touch or interact with any

of it or even hardly hear it. I was cruelly encased away from connection, tormented by seeing the unattainable. This is perhaps why I fantasized about the padded room. It represented my state more accurately.

My perceptions are valued and needed. It's how I figured out I could write this book. I started to see for the first time the importance of the space that I take up. I get to use my voice, my pictures, my words and my experiences to be out loud and known. It is my automatic tendency to stay hidden. I get to be confident and reveal myself.

It has been nearly unbearable at times, to take those first steps in revealing myself. I had gained just enough confidence and inclination to do it, but it still felt painfully uncomfortable. I got brave enough to not be afraid of *not knowing* and ask questions of my instructor, friend, mentor, therapist, doctor, and myself. I have always been terrified to ask questions. It feels as though I will be exposed as a fraud if I do. I am figuring that everyone else already knows everything and I am the idiot who is still in the dark for some reason.

As I watch other people ask questions, I realize that they have plenty of *not knowing* and that I was so grateful to them for asking their questions because it served to reveal a wealth of things to me as well. I started to connect the dots and realize that it would be

to the benefit of all for me to also put myself out there and ask my questions.

The first time I got up enough guts to ask a question in front of strangers, I found my hands shaking, my heart racing and it took me a good five minutes to calm down afterwards. With practice, I am getting a lot better at putting myself out there in unfamiliar situations. I am seeing how much we are all in this thing called life together. It is beautiful to see and be seen, our spirits and energies touching and colliding.

Sharing Art

THE OTHER SPACE I had decided to challenge myself to take up and be seen is with my art. I am still really working on that one. My art feels vulnerable, personal, and intimate to me. I have only allowed myself to work in my art journals so far. I have let my fear of a canvas stop me from trying. It feels nearly excruciating to share it with others. I had begun to feel this clear premonition to share a piece that was pivotal to me on my journey to healing.

I was wrapping up my treatments for TMS with Dr. Gardener. They kept asking me to bring in my art so they could see it. I politely said, "Okay." While I felt terrified and bewildered inside, I finally decided to frame and wrap up this significant piece that had begun my journey with the healing I received from their team. It was deeply

personal to me. It felt extremely painful to think of being so publicly exposed. I knew though, that despite all my fear and dread, that it was a really important step for me in moving forward and outside of this cage of myself.

I also felt encouraged and affirmed by all the artwork that Dr. Gardener had around her office. She had collected it from around the world, and they were all beautifully raw expressions of emotion. I was ministered to every time I came into her office. It gave me a clear validation of permission to express and be seen in my core. The evidence was there on the canvas from the souls of others.

After I gave my picture, I felt sick about it for days. I was super emotional and discombobulated. Until one day my friend said, "It sounds like you are having a vulnerability hangover." Yes indeed! That was it. It is not always easy or comfortable to put my most authentic self out there. But wow- it is powerful and deeply fulfilling. I am learning to recognize the place that I hold in the world and see the possibility of my value.

I also took a big step in leading and facilitating a small group of close friends in expressive arts. I hate having to be in charge, directing, and telling other people what to do. It feels so awkward and unnatural to me. I hate inserting myself. I guess I was compelled to do it because I had become so passionate about using art as a form

of expression and language. I was fascinated by the process and exuberant to share and experience this with others. I figured out how to ignore all my fears and intensely awkward feelings in order to share what I was doing.

It is an exciting surprise to see what comes out of each person's unique language through imagery and color. I would become distracted from my discomfort by being engaged in the process with others. I also got to see the impact of what I shared. I saw how I was presenting a new and untapped experience. I should not be shy to share more details of what I have learned from the hours and years I had spent studying and learning on my own. My drive to learn about this particular thing is something valuable to pass on. This was a space for others to get to reckon with the knowledge I had gained through my own compelling passions. I saw that they were impacted and blessed by my sharing. Now, if I can just get brave enough to share this more broadly. Perhaps that is what I am doing right now in writing this book. I am daring to be connected. I am recognizing a place I hold in the world.

Sacred Spaces

A SMALL GROUP of my friends began to gather weekly, some in person, some from other countries and other cities, for the purpose of doing expressive arts together. We were all in this crazy transition in life having children ranging in ages from 6 to 16. Our kids were still home even after spring break had long passed. We had somehow become full time teacher assistants, educational facilitators, lunch ladies, janitors, PE coaches, art, theater and music directors. We had been ordered to stay home, only to go out to get groceries and be really afraid because the plague was coming. You could say that we were severely disoriented.

We found this beautiful space open up as the need had arisen to gather together for a few hours every week and share our hearts

through imagery. We shared our struggles. We cried. We made raw art to express and discover the language of our souls. We found hidden parts that had gotten lost in our inner shadows. We affirmed and spoke into each other's hurting spaces, and we laughed with joy for each other's triumphs. It was a magical space of recognition and respite.

Once again, I saw that there is a power in our connectedness. Holding that safe space to be candid, authentic, and visible. And to sit quietly in order to see what wants to arise. I am seriously amazed every time. It's still hard for me to believe how it works. It is kind of just on faith most of the time that when I show up to a blank page, it will actually reveal something to me. But my confidence is building as I spend more and more time in this arena of raw arts expression and hearing my intuition.

I have also seen some insanely powerful artwork come out of folks who have no technical art skills. The power of expression is honestly in how vulnerable we are willing to be. I've seen it so many times in my own stuff. The more I am completely open, vulnerable, and not trying, there is a poignant power in the piece. I've seen the most tremendous expressions come out of my green, amateur friends. I sort of have this vision to do an art show some time with only non-artists and their expressive, raw art pieces. I've heard tell

of it being done. I just love the idea of displaying the possibility and power that every one of us can have, eradicating limiting beliefs.

Finding My Storyteller

WHEN I BEGAN the desperate road to healing, there were so many things I did not know and did not know that I did not know. I was in such a muted state. I first had to recognize that I do have a story. A valid story of what life had brought me so far. What are the facts? I grew up with loving parents and a mother that had chronic illness. I spent my adult life pooling resources to help take care of my parents. Now, it was a matter of detangling the story I had woven for myself from those facts.

What story was I living out of that my very young brain had fashioned for me? "You need to stay small and not need anything. Taking care of others is your top priority. Stay small, invisible and out of the way. Try not to take up space."

Now, I am a mature, middle aged adult figuring out that I not only get to discover what story I have been telling myself all my life. I also get to ask what I want my story to be. How do I want it to tell? What is story? Creation and life vibrating forward. How do I shape into my own story-teller?

I first get to recognize that I am valuable - to validate myself. To humbly accept the creature that I am. Be grateful for everything that I do have. And make a choice to have authority over my life, my domain. I get to learn how to hear and trust my intuition.

How do I want to re-tell my story? What was the story I was carrying? I am a victim of life circumstances and helplessly apathetic to do anything about it. This had left me limp, tossed and turned by whatever life threw at me. No choices. I was forever overwhelmed (not being present and intimate with myself). I had absolutely no problem-solving abilities. I needed to confidently recognize that I have choices. I am not trapped. When that first resonated with me, it felt like this glorious loophole out of feeling subject to everything. That helpless feeling had turned into sheer panic, anxiety, and the absolute pit of depression. I began to exercise the muscle of seeing options in every scenario to liberate myself out of whatever I felt a victim to.

Slowly, so slowly, my eyes opened to the possibility of a new world. I asked myself, "What is the new story I want to tell and

know about my life?" I had a loving and intimately connected family through crises. I loyally stood by my mother and father through so much suffering with a deep willingness to sacrifice. Although I put many of my own things on hold to support my parents, I gained incredible wisdom and insights into the deeper significance of life and found a true, more pure and authentic relationship with God. I am not condemned but valued. I found my power and strength to crawl out of some incredibly hard places through my willfulness and perseverance.

I learned a trick from my therapist about taking my emotions to court. This is a perfect way to identify my old paradigm (story) and reframe a new one. It was liberating. I still use it when I find myself stumped by my reactions to things or when I am triggered by a situation. I start filling in the grid.

This helps to draw out what it is that I perceived from the trigger and discover the actual source of the negative emotion. When I reframe a new possibility, it gives me an option to see the situation in the potential of another lens, without the past discrepancies that I am projecting on this new and innocent situation. Then I get to affirm my reaction's validity from the place of wounding while also giving full credence to the reality of the current scenario. I get to both see my deeper, inner story (possi-

bly heal in the accepting of that), and encounter my current life with so much more freedom. Not dictated by my past sorrows. I became unencumbered and enlightened.

I believe this was the precursor to getting to delve into and claim my intentions for my daily and broader life. What does it look like to have intention, to draw up intention and choose it? I would find it in this quiet space of trusting myself. Believing that I inherently know deeper truths. I have wisdom and knowing woven into me.

I began approaching each day from that quiet space of letting my *under parts* speak. I found an exercise that really helped warm me in my new practice of claiming intention. It involved spontaneously cutting or ripping out just one image and one word from a magazine and pasting it into my journal. This would initiate a vision from the undercurrents of myself. It was a validation and affirmation. It helped me to be in tune to my more subtle energies. My whole human being invited into each day. I found this gorgeous and inviting energy inside of me that was thrilling to encounter and incorporate into my regular everyday life. It brought new exciting energy, stamina, focus, and vision to my day. I got to feel a deeper purpose driving me.

We are talking really simple stuff here sometimes that I was looking to find a vision for. Like how to encounter my house that felt messy, disorganized, and chaotic. Instead of feeling overwhelmed by

it, I became intimate and present with myself and saw a vision forward. I know it sounds kind of silly to get so profound about household tasks, but I was coming from an extremely paralyzed place. Not having the first clue how to encounter life. Everything felt so weighted. It was liberating to see a path forward. It gave me that rewarding sense of accomplishment. A validation of participating, not because I felt like I was supposed to, but because that was exactly what I wanted to do for myself.

Of course, jobs and duties come into play with the needs of my children. I began to find an ease with fulfilling those things because I recognized for myself how I wanted and loved these little souls. I choose them, so I also choose driving them around, playing games with them, feeding them, and helping them with homework. I was following the deep and powerful seeds of my intentions. They were generating their own force of energy and power. Those were the first baby steps to validating my existence. From there, I could validate myself more broadly in a bigger sense in the world.

Oh, and I should mention that there were multiple times (I better not mention how many) that I was confident that I did not want to be a mother anymore. I hope my kids can put this in context when they read this. I felt so withered and emptied of anything left to push

myself forward. I had begun to fantasize about moving out into a cabin in the woods by myself.

One time I was at the airport on my way home from a trip to the Olympic Peninsula. I was talking to John on the phone from the airport, telling him I'm not sure if I can come home. I pictured myself in a cabin on a seaside cliff with my books and typewriter, watching winter storms rampaging the rocks. "Just for a month," I said. "I think I could come back home after that." John sympathized nervously as he heard the seriousness in my voice. I was desperately longing for a deep rest. Crisis and trauma had ravaged my resources. I was plundered and consumed. I was beginning to allow myself to see the possibility to a path of rest.

Just recently I found this little one bedroom cabin on the Texas coast that I contemplated renting for a month to take my respite. I told John encouragingly, "You guys can come and visit me on the weekends." For now, I am beginning to account for what deep rest looks like incorporated into my regular daily life.

Worthiness of Deep Respite

I REALLY WANTED to know what it would look like to have respite incorporated into my daily life. Did I even know how to let down all the way? I was so steeped in that heightened feeling of crisis. I worked to really tap into that subtle undercurrent of crisis operating. It made everything, even the small things feel so stressful and consuming. It also made it really hard to handle very much because I was always exhausted from the intense over-stimulation.

I began to give myself permission to disengage from the life whirling around me. To be still and take in the organic, sensual experiences waiting to sweep through me. I find the best way to do this is outside with the birds twilling in my ears, the breezes fluttering my skin, and leaves rattling the air. Insects buzzing in

their hidden spaces. The coolness or warmth testing out their temperatures on my bones. The sun is a penetrating muscle massage. The moon reflecting a mysterious illumination that reveals something too glorious to look at, yet I experience the glory through its reflection. Acorns and leaves tickle and drop around me, sometimes plunking themselves on my head. This is all due to the playfulness and vigor of the squirrels and their Fall gorging. Seasons and rhythms are naturally pulsing themselves all around me. I get to let down and trust in their inherent wisdom. I get to feel this indescribable grounding that holds the very core of my heart in its compassionate and loving grasp. I feel essential, even in this vastness of intricate creation. I breath in this deeply felt harmony and let it flood every recess of my soul and marrow. My body, mind, and spirit united. Its glorious. It's deep rest being present and intimate with myself.

It's coming alive this Spring. Opening up the scents and fluorescent greens glowing against bruised sky. Bulbs are pushing and pressing up to the blue. Buds come, longing for release. Carrots are plump and sweet still tucked into the earth. Peas are nearly bursting their green pockets.

I am new with wonder and also weary from my travels in this life. My future is blown wide open with change, transition, and

ownership. I am excited to embark and see my hands hard at work, thoughtfully planning from my deepest intentions.

I am loosening the burdens from my past, the hardness that my heart guarded. Seen, realized, and released. My energy is spent for new instead of old. Now when I walk in the forest, I feel my soul cleansing fully because there is nothing blocking. My soul can be a pure and true vessel that awakens the joy and mystery in life and finally the longing to start each new day. The light has come. The dark valley is behind me. I hold its lessons solid like a foundation. I get to let down and be seen. I get to be visible after hiding in a deep, long shadow. I am now detangling this story from my soul. Like the roots of a tree plunged deep into the earth, ready to stretch its branches toward the light. The bonsai is beautifully twisted from what it has endured. It's telling its story that is asking to be heard and known in all its glory of endurance.

After these precious moments of being, I return to my life and duties with a deeper inertia of energy. I feel purposeful, a part of something universal. I feel lighter, held by something bigger instead of carrying the weight of it all on my lonely shoulders. I feel less serious, more sober, playful, and carefree. Perhaps a little feral. I am not meant to be an utterly tamed creature. I have been given a wildness that wants to feel itself sometimes to know that it is there, that

it is fierce and wonderful. To be spontaneous and activated. To feel the wild waves of a vibrancy crashing over my head in exhilaration at their intensity of playfulness and power. I want to feel my own power mirrored. To feel ecstatic about participating and displaying. I am invigorated, fed by the very earth that holds my sustenance.

In this state of regularly renewing deep rest, I find a space open up to be in tune to my intentions. I can quietly let my intentions float up each day to guide me and give me directions in alignment with my passions. Is this being streamlined into seamless connection with the Creator? I feel an energy of something gorgeous inside of me. I feel an innocence returned that is sweet and wants beautiful and wonderful things. That is compassionate and giving.

Gratitude does a lot to preface this state of purity and innocence. I feel my guile released. Permission to be dismissed. It is the antithesis of being condemned. If innocence is the lack of guilt or sin, finding my path back to this sweet nectar of innocence puts me in the correct state I was meant to be in. I am not condemned by this life here on Earth. I am liberated by accepting my humility and my power. I influence, and I am in humble gratitude. I choose to be in this framework of vibrancy, participating fully in the vibrations of this living canvas.

THIS IS NOT THE END BUT THE BEGINNING

Acknowledgments

I WISH I could measure the writing of this book in tears. I am thankful that I was brave enough to show up each day and face the deeper emotions of my experiences.

I would first like to acknowledge John, for standing by me soul deep in this adventure of life. You claimed me as a strong whisperer.

Marius, Tristan, and Erik, thank you for how much you respected my work of writing. You have honored the space I held for it.

Adam and Jody, oh how do I say the depth at which I feel tied to you two? Our hands are intertwined intimately on the road of suffering and finding new life!

You are a brave, brave man dad. You kept going faithfully beside your wife through the relentless thick, missing a lot of the thin.

You never complained. Thank you for not giving up after mom died. Thank you for validating my intuition.

Aunt Joy, thank you for coming to our rescue countless times.

Thank you Heather for being my sister.

Jeremy and Caroline Fichter, thank you for holding us while we hurt for all those years of crises in Seattle.

Ray and Liz Strand, thank you for profoundly standing by our family in ways I am only just now taking in.

Erin Martin, thank you for being there and helping to carry me along when I could barely carry myself.

My art girls, thank you for the sacred space you held and for encouraging me to be a strong whisperer.

Uncle Ted and Aunt Missy Williams, thank you for taking me in, holding me generously and showing me that I am worth healing.

Dr. Crawford, thank you for your beautiful gift of guiding to heal from deep within the heart. You helped me see the light.

Dr. Gehlber and staff, thank you for the gentle work of healing you do.

I am deeply grateful for my Texas commune community. You all held me so softly during some of my darkest times.

Thank you Shelley Klammer for insightfully articulating the world of art therapy. Your expressions of wisdom helped to transform my life.

Juliana, Amber and Alli, thank you for delving into my messy draft with me. Your insights spurred me on with inspiration.

Tom Hart, thank you for showing me through *Rosalie Lightning*, how excruciatingly beautiful it is to share your story.

Valeria, you jumped in knee deep with me and cheered me on through the gift of you.

Sage Adderly, thank you for being a tremendously wise intuitive coach. I am so grateful I found you!

About the Author

Andrea Pardue is a simple soul who has meekly braved each step of her life's joys and hardships. She discovered the expressive arts as therapy in her darkest moment, studied her guts and soul out to find her way to a liberating, feral freedom to participate in life again. This is her first book. She lives with her husband and three boys in Texas. A piece of her heart remains on Whidbey Island. She leads small groups in expressive arts and loves to hear the soul stories of others. You can contact her at andreapardue44@gmail.com or www.strongwhisperer.com.

Disclaimer

This is just my experience. I place no all-knowing claim on anything. I am wildly far away from theology. I only know what life has taught me and what rings truth beautiful in my heart. I am grateful for having a personalized, custom relationship with the Creator. I love that no one can refute or take that away from me.

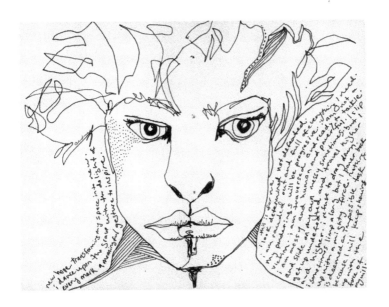